IMAGES
of America

WEST BOYLSTON

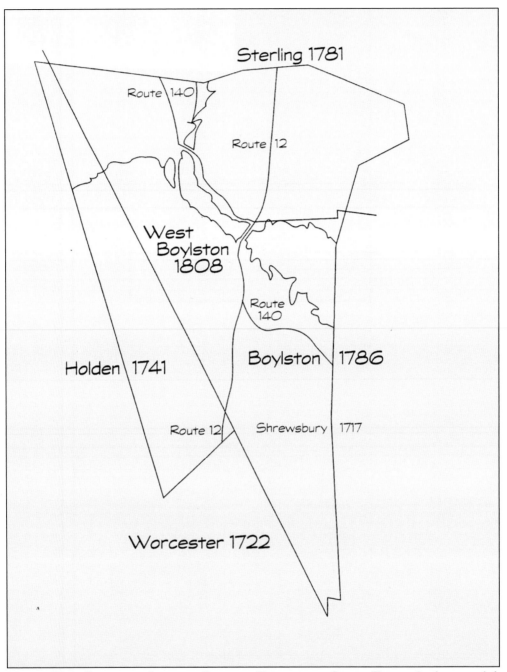

MAP OF WEST BOYLSTON, SHOWING SECTIONS TAKEN FROM OTHER TOWNS. In the upper left corner is the Shrewsbury Leg taken from Sterling. It had once been in Shrewsbury. The area in the upper right was originally part of Lancaster. The lower left section came from Holden and was previously in Worcester. The rest came from Boylston, which was once part of Shrewsbury.

IMAGES
of America

WEST BOYLSTON

Frank A. Brown and Beverly K. Goodale
for the West Boylston Historical Society

ARCADIA
PUBLISHING

Published by Arcadia Publishing
Charleston, South Carolina

Printed in the United States of America

Library of Congress Catalog Card Number: 2005932364

For all general information contact Arcadia Publishing at:
Telephone 843-853-2070
Fax 843-853-0044
E-mail sales@arcadiapublishing.com
For customer service and orders:
Toll-Free 1-888-313-2665

Visit us on the Internet at www.arcadiapublishing.com

On the cover: The cover picture shows The Cowee family float lining up in front of the Congregational church for the 1908 Centennial Parade.

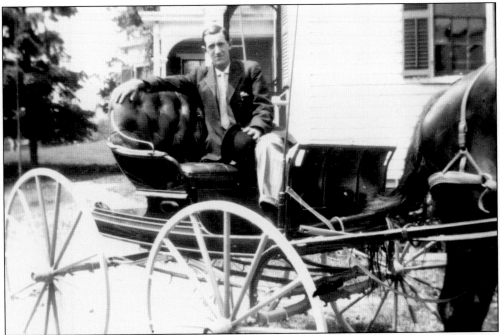

CARRIAGE PREPARING FOR 1908 CENTENNIAL PARADE. The horse and buggy have not been replaced by the automobile yet. (Courtesy of Dennis Parker.)

CONTENTS

ACKNOWLEDGMENTS

As we are sure you all know, it takes a lot of folks to put together a project of this magnitude. We would like to thank the following for their assistance in bringing this work to fruition. We are deeply indebted to photographer Patrick J. O'Connor for all his efforts on our behalf, and to his wife Sarah, our proofreader. He spent countless hours photographing and tweaking pictures. We are grateful to the Beaman Memorial Library for allowing us to photograph pictures from their collection, and particularly to Steven Carlson for his help. Most of our photographs came from the West Boylston Historical Society archives. We are grateful to all the people who have donated their family pictures to the society over the years and also to the Metropolitan District Commission for their foresight in photographing all the buildings in the towns that would be destroyed for the reservoir. We also have included some pictures from the following people: Rockie Blunt, Aaron Goodale, Norman Goodale, April Whitcomb Gustafson, Barbara LaComfora, Jim Mulroy, and Dennis Parker, as well as the Edwards School.

INTRODUCTION

The area that is now West Boylston, Massachusetts, was first settled in the 1720s, and all or parts of it were at various times in the towns of Lancaster, Shrewsbury, Boylston, Holden, and Sterling. In the 1790s, like many Massachusetts towns, West Boylston separated from Boylston in a dispute over the location of a new meetinghouse. It was for a few years classified as a precinct, and in 1808 it became an independent town. The leader in this process was a larger-than-life character named Ezra Beaman. He was an innkeeper, a farmer, a manufacturer, a selectman, a state representative, and a Revolutionary War major.

The original town center was exactly where it is today with the common, the Congregational church, and the Bigelow Tavern (now the historical society headquarters). In the 1830s, as industry developed, the center moved gradually to the area around the rivers. The old center became a quiet, thinly-settled area on the road to Worcester.

Through the 1800s, the town had a variety of industries: textiles, boots and shoes, a gristmill, and an organ builder. Workers immigrated from French Canada and Ireland. Many of the original families turned from farming to manufacturing. West Boylston was a prosperous community, with two hotels and its own bank.

However, the reason for the coming of the factories was to be the cause of their destruction. West Boylston contained the junction of three rivers: the Quinapoxet, the Stillwater, and the South Branch of the Nashua. The center of town had developed around this junction to take advantage of waterpower for industry. In the 1890s, the State of Massachusetts recognized the abundance of water as ideal for a reservoir.

Over the next several years the whole center of the town and almost all the industry were destroyed to create the Wachusett Reservoir to provide water for the growing city of Boston. The neighboring towns of Boylston, Clinton, and Sterling all took losses as well, but it was land on the edges of town.

Because the original center, away from the rivers, remained unharmed there was a place to move back to when the reservoir came. Some residents had their houses moved, pulled slowly along the roads by horses and oxen. Others built new houses, but because of the lack of jobs, many people left for good, and the population was greatly reduced.

Actually, because it was a farming community before the Industrial Revolution, there are many 18th- and early-19th-century houses strung out along the main roads in the area not touched by the reservoir. Of the buildings in the reservoir area, only one remains—the Old Stone Church, West Boylston's principal landmark. It sits alone on a point of land by the side of the water, visible from Routes 12 and 140, and is one of the most photographed sites in Massachusetts.

The building of the reservoir is a story in itself, done before the invention of much power equipment. The workers were mostly imported from Italy, and many stayed on to become an important segment of West Boylston's population.

The village of Oakdale is contained within West Boylston. It was on the fringe of the reservoir and only the first few blocks of streets were taken by the state. Very little else has changed since the town developed in the mid-1800s, a picturesque village of Greek Revival houses. Its most famous resident was Robert Bailey Thomas, the founder of *The Old Farmer's Almanac*. For the first many years of its publication, the almanac was compiled in what is now West Boylston.

During the 20th century, the town gradually saw its population restored as it became a "bedroom town" for its larger neighbor, Worcester. Some new light industry developed as well as a retail strip along the old trolley path, West Boylston Street (now Route 12). The town was able, however, to maintain much of its rural beauty, somewhat because of the preservation of forest land for the protection of the reservoir. In an odd twist of fate, the reservoir saved West Boylston from being a drab, fading mill town.

Finally, there should be mention of the restoration of the Old Stone Church. In the 1970s, after years of neglect, the side walls and roof fell in. Through the efforts of the historical society, the historical commission, and the Beaman Oak Garden Club, the state was persuaded to rebuild the damage, and the church was returned to its former appearance. Today it is a popular place for weddings, and "leaf peepers" stop by there in the fall.

EDGAR A. WHITCOMB. This book is dedicated to Edgar A. Whitcomb, 1929–2004, West Boylston's historian. With his help, creating this book would have been much easier. Without the research he left us, it would have been impossible. (Portrait by his daughter, April Whitcomb Gustafson.)

One

THE EARLIEST DAYS

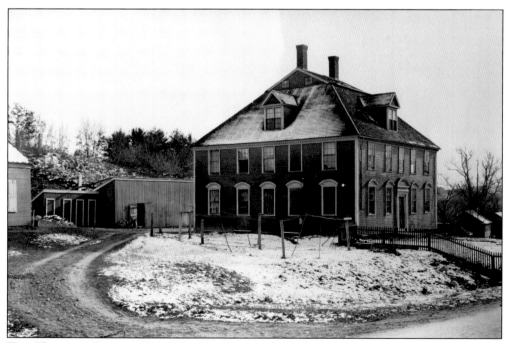

THE HISTORIC BEAMAN TAVERN. Ezra Beaman built this tavern to replace his father's inn, which had been destroyed by fire. This picture shows the building after it had ceased to be an inn when Ezra Jr. died, and had been moved a little away from the Beaman property. Not long after, it would be destroyed for the reservoir. No picture of Ezra himself is known to exist.

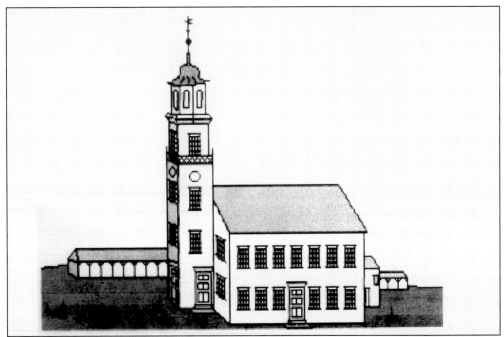

THE BEAMAN MEETINGHOUSE, THE FIRST CHURCH IN WEST BOYLSTON. The Beaman Meetinghouse stood right where the present Congregational church is today. Ezra Beaman's construction of this building marked the beginning of West Boylston's existence as a separate community. It was dedicated in 1795 and served as church and town meeting hall until struck by lightning in 1831.

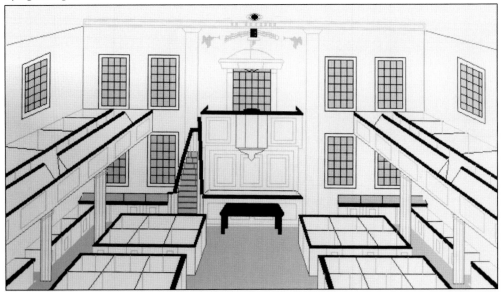

THE INTERIOR OF THE BEAMAN MEETINGHOUSE. This picture is a re-creation based on a description by the Reverend James Fitts, pastor in the 1860s. He would have known people in the parish who remembered the church before it burned in 1831. Between those recollections and the details common to Congregational churches of the period, this picture is probably reasonably accurate.

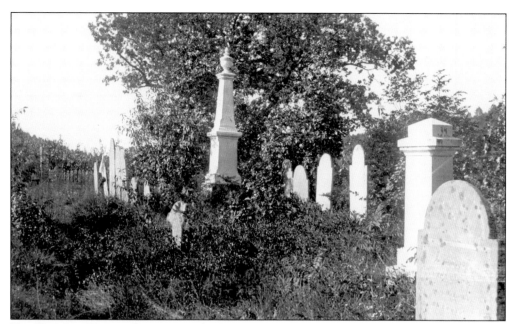

THE BEAMAN FAMILY CEMETERY. The Beaman property covered a large area east of the north end of the present causeway (now in the water or along the edge) and included this burying ground. In 1904, it was moved grave by grave to the Mount Vernon Cemetery. The tree is the ancient Beaman Oak, which was lost to the reservoir, but can still be seen on the town's seal and flag.

THE HOUSE AT 65 WORCESTER STREET. It was originally the Bigelow Tavern, probably built in the 1770s, later the Temple Tavern, the Spofford Inn, and Shepard's turkey farm. The barn and the porch are gone, and the house has been restored to its 18th-century appearance. It is now the headquarters of the West Boylston Historical Society.

THE TEMPLE DISTILLERY. It was probably built by Deacon Amariah Bigelow about the same time as the tavern. When the Temples owned the inn, it was their winery and distillery. At one time it also served as a parsonage for the meetinghouse and finally as a private residence. With the house next door and the tavern across Worcester Street, it comprises a mini historic district.

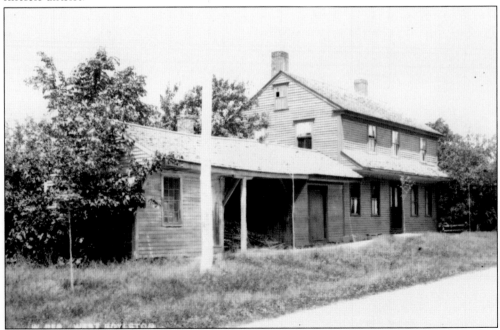

THE GIBBS STORE. Early on this building belonged to the Bigelow and Temple families. Built in the late 18th century, it was used as a store. Town meetings were held on the second floor. It was said that at one time as much as 100 gallons of St. Croix and New England rum were sold here per week. It was also known as the White store. Today, it is a private residence.

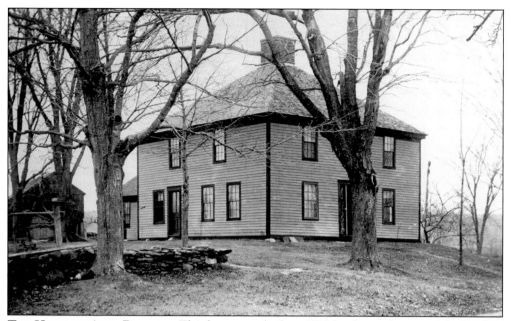

THE HOME OF ABEL BIGELOW. This home was built *c.* 1779 by the innkeeper of the Bigelow Tavern. His grandsons Horatio and Erastus were the founders of the famous Bigelow Carpet Company in Clinton. The house remained in the family into the 20th century and is still standing on Temple Street. The street took its name from the Temple family, who inherited the tavern from the Bigelows.

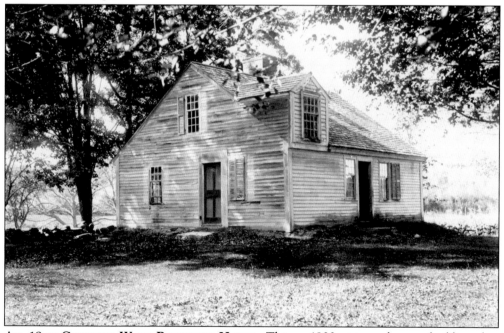

AN 18TH-CENTURY WEST BOYLSTON HOUSE. This *c.* 1900 picture shows a building that remained largely unchanged, although the unusual off-center gable might be an addition. The house, now destroyed, was the last building in West Boylston on Worcester Street near the Worcester line.

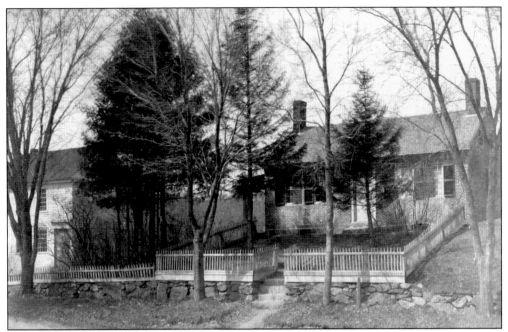

THE REED CARPENTER SHOP AND BRICK HOUSE. This property, on what is now Central Street, was built in the 18th century by Antipas Harthan. The 39-acre lot was bought in 1839 by David Reed. His granddaughter Mary Jane inherited it. She married Waters Warner. They removed the brick house and built a 10-room home. The carpenter shop was demolished in 1908.

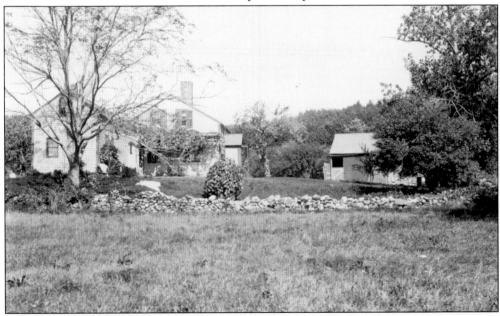

JACOB WINN HOMESTEAD. Jacob Winn was an original settler and a cooper by trade. The house on Lancaster Street was built between 1745 and 1765. Later, it was the home of May Cook, the West Boylston correspondent for the *Worcester Telegram*, whose columns have provided a rich record of the town's history around the beginning of the 20th century. The Metropolitan District Commission bought the house around 1900, and the state still uses it.

DAVID AND MARY REED. David Reid was born in Londonderry, New Hampshire in 1804, and came to West Boylston as a young man to learn the carpentry trade. He made fanning mills for the winnowing of grain. In 1834, he married Mary L. Marsh of Chesterfield, New Hampshire, also born in 1804. It is interesting to note that David, who was Scotch-Irish, changed the spelling of his name to Reed to please the English Reeds already in town. He was one of four men instrumental in starting Mount Vernon Cemetery.

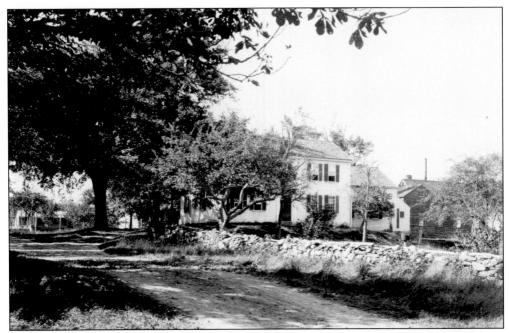

LEVI PIERCE HOUSE. Known as "the Wayside," this was a dairy and fruit farm. Built around 1790, it also housed a flourishing basket-making business. William Nash, the first minister, after retiring to nearby Maple Street, was said to come here frequently for afternoon drinks. The Pierce family gave their name to the street and retained ownership of the house until 1960.

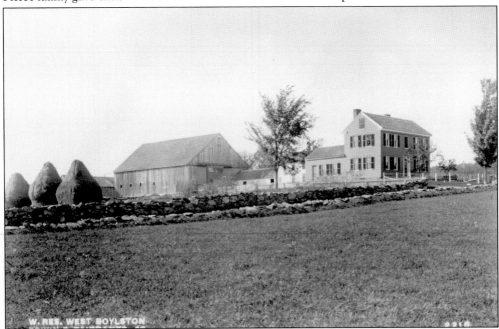

BARUCH FAIRBANKS HOUSE. This brick, Federal–style house on Prescott Street was built in 1803, on land given to Baruch by his father, Lemuel. Married to Sally Lovell, he was a carpenter by trade and ran an extensive farm as well. It was later owned by the Lovell family, then again by the Fairbanks family, as there was quite a bit of intermarriage between the two families.

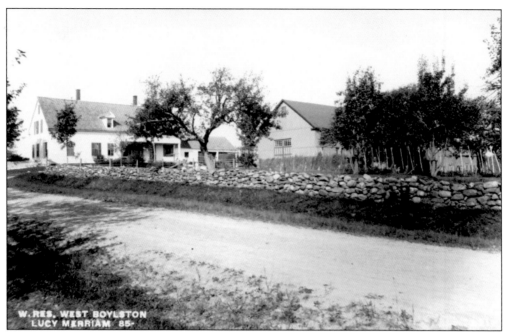

LEMUEL FAIRBANKS ESTATE. This homestead was built on or before 1790, on land given by his father, Jonathan Fairbanks, who held the original land grant. Lemuel was a Revolutionary War soldier who answered the call on April 19, 1775. The house still stands on Prescott Street, much as it was, minus its outbuildings.

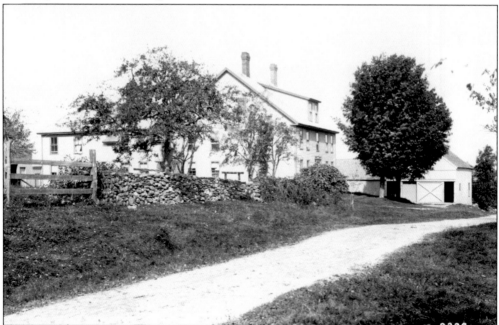

FOUR WINDS. This house on Prescott Street, built in 1829, was the pauper farm for West Boylston and Sterling between 1877 and 1923. It was a place of refuge for the poor and later for tramps seeking work on the reservoir project. Cost per inmate in 1885 was $2.33 per week. Later it became a gentlemen's farm.

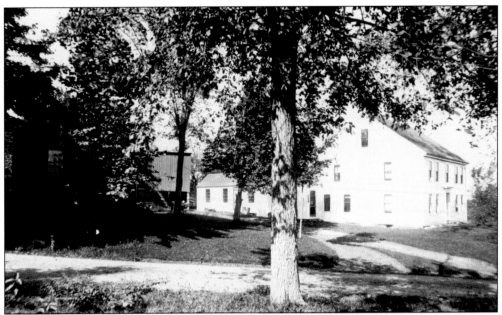

BENJAMIN KEYES HOUSE. It was built in 1784 by Thomas Keyes, an original settler and a minuteman who marched on April 19, 1775. This farm on Prospect Street was left to Thomas Keyes Jr., and he left it to his son Benjamin, who lived there all his life. Benjamin was active in town politics and wrote a history of the town in 1858. The house remained in the family until 1951.

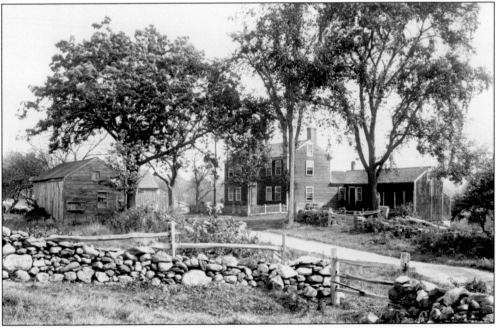

THE HARVEY PRESCOTT HOUSE. This early home was on Prescott Street going towards Sterling, beyond where the railroad tracks are now. It is likely that this house gave the street its name. It met its demise when the Metropolitan District Commission took the land for watershed protection in the early 20th century.

OLD BLACKSMITH SHOP. This shop was built probably in the 1790s on the road to Boylston that ran along what is now the northern fringe of the reservoir. This was where Ezra Beaman had his extensive properties. It is thought to have been the first blacksmith shop in West Boylston, and may have been a Beaman project, although about 1898 when this picture was taken, the building was listed in the name of Sturtevant.

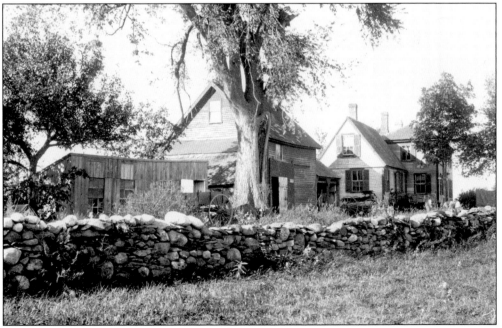

ZACHARIAH CHILD HOUSE. This homestead on upper Maple Street was built in 1801 in the Federal style, either by Zachariah or by his father, David. Zachariah was a Revolutionary War soldier, and the father of David Lee Child, the prominent abolitionist editor, who donated the funds for the first West Boylston Library.

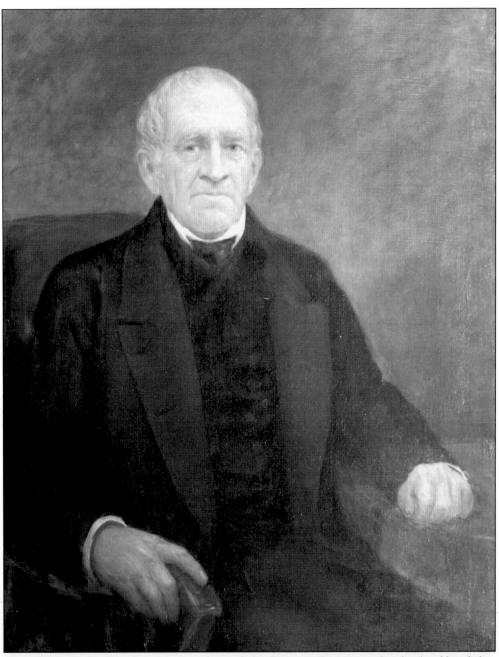

EZRA BEAMAN JR. Ezra Beaman Jr. inherited the Beaman Tavern on the death of his father in 1811 and ran it for the rest of his life. He was never the dynamic character that his father was, but he was an important man in town and known to everyone as "Uncle Ezra." He never married, so while his sisters provided many descendants of the elder Ezra Beaman, there are none named Beaman. (Courtesy of the Beaman Memorial Library.)

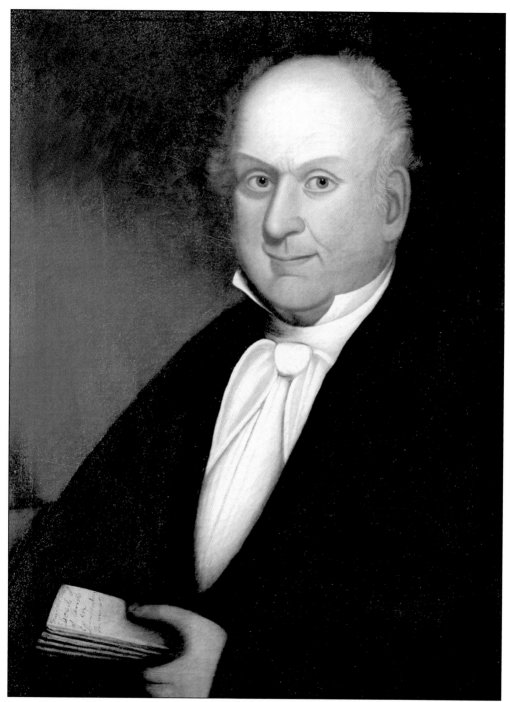

JOHN TEMPLE. John Temple was born in 1762. He was the eldest son of Jonas Temple who was an early settler and Revolutionary War soldier. His second wife was Persis, daughter of Ezra Beaman. He was a successful farmer and owned most of the land in the southern part of town, as well as the former Bigelow Tavern. A very civic-minded man, he served several times as chairman of the board of selectmen. (Courtesy of the Beaman Memorial Library.)

DR. NICHOLAS JENKS'S HOUSE. Built in 1810, this Federal–style house soon became the Congregational church parsonage and home to the Reverend John Boardman. Later Charles Morse ran a school for unruly boys from Worcester here. The attic is partitioned for sleeping quarters for the boys and the living room served as a classroom. Today it is a private residence.

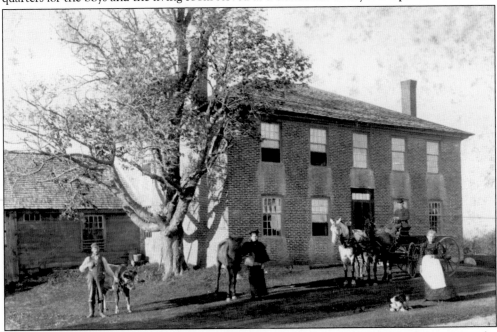

EDWARD AND SARAH GOODALE HOUSE. The Goodales came here in 1738 and are among the earliest settlers. Three of their sons answered the call on April 19, 1775. Shown in this picture c. 1900 are, from left to right, Joseph Goodale, his daughter Helen, and his wife Elizabeth. In 1927, the Wachusett Country Club was built on this site.

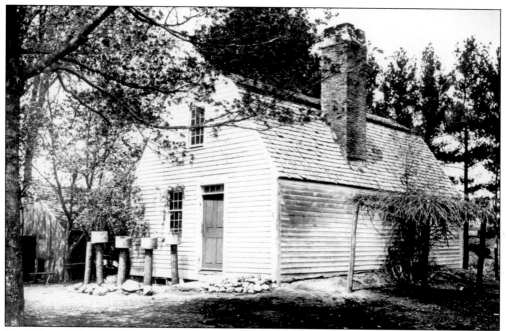

THE HINDS HOUSE. Benjamin Hinds and his son Jacob were among the earliest settlers. Their house stood where the Scarlett Brook shopping mall is now. There was no street there then. West Boylston Street (Route 12) did not appear until the 20th century. The house was destroyed by fire years ago.

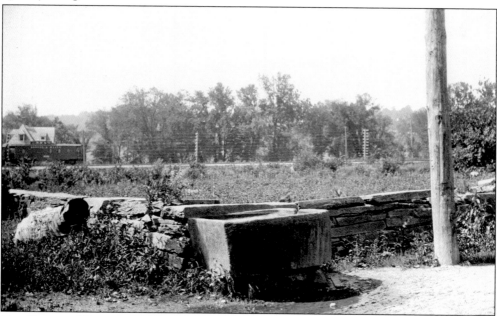

THE BEAMAN WATERING TROUGH. Ezra Beaman placed the watering trough at his tavern in 1808, the same year the town was chartered. Ezra filled the trough with rum punch on its first day of use, much to the delight of the townspeople. When the reservoir came, the trough was saved. After many years at a spot in the Maple/Worcester Streets area, in 1930 it was moved to its present location in front of the Beaman Library.

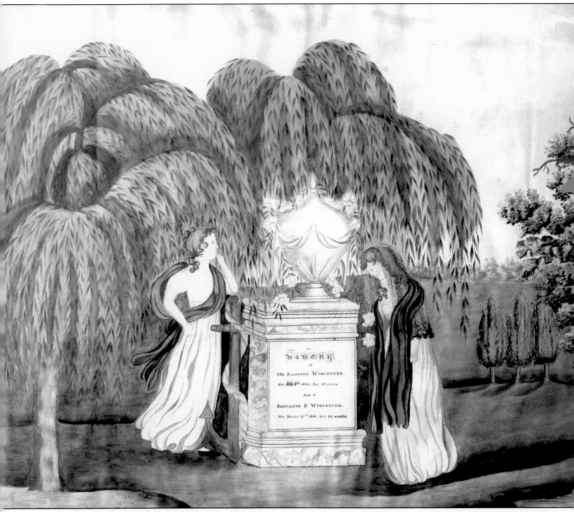

PHEBE WORCESTER'S MOURNING PICTURE. This is a type of painting popular in the early 19th century. It represents a real grave in Mount Vernon Cemetery, that of Sampson Worcester, who died in 1821. The monument and the setting do not look quite the same because these paintings were mass-produced and sold in unfinished form to be completed with appropriate names and details by the family. Phebe, shown as the grieving widow in the picture, was herself buried here later. The Worcester family was related by marriage to the Holbrooks (see chapter two), whose monument is nearby, and in whose memory the cemetery chapel was given. (Courtesy of the Beaman Memorial Library.)

Two

THE INDUSTRIAL
REVOLUTION

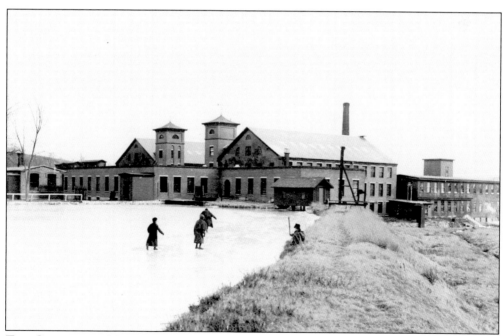

THE CLARENDON MILL POND. In the early 19th century, Ezra Beaman, with advice from manufacturing pioneer Samuel Slater, founded the Beaman Mills, later the Clarendon Mills. He created this reservoir, long before the Wachusett Reservoir came.

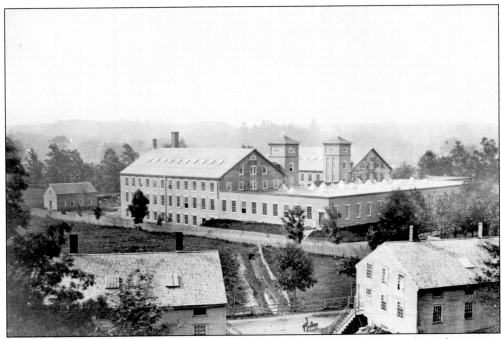

TWO VIEWS OF THE CLARENDON MILLS. These buildings, along with employee housing, a school, and a company store stood on the Beaman property, which comprised what is now the whole of the far eastern side of the reservoir, roughly from the present causeway almost to the Boylston line.

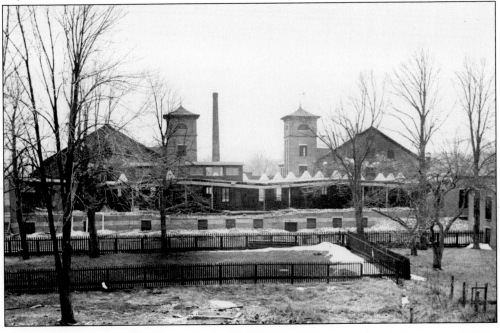

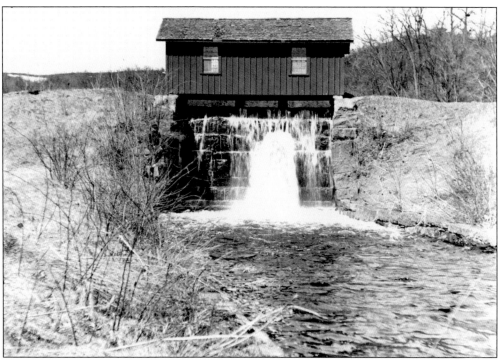

THE GATEHOUSE AND SPILLWAY. These were part of the Beaman/Clarendon waterpower system.

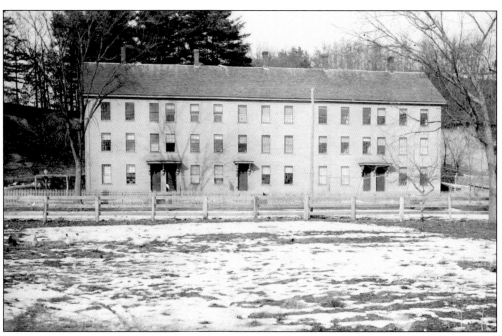

MILL HOUSING. During the Industrial Revolution, the average West Boylston citizen was a farmer and fully occupied working on his own land. A large proportion of the mill workers were immigrants. Most were French Canadians or Irish. The manufacturers built tenements like these to house them and their families. These are believed to have belonged to the Clarendon Mills.

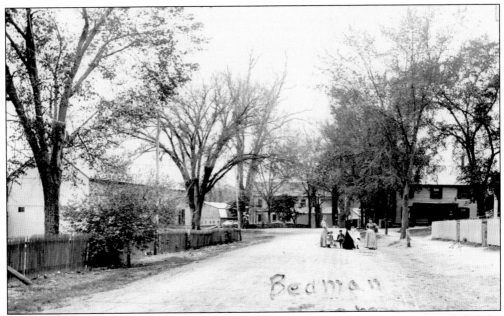

THE BEAMAN FARM. This was the center of Ezra Beaman's vast property, which included the Beaman Tavern, the Beaman Watering Trough, the Beaman Oak and the Beaman Buttonwood Tree, the Beaman Mills, the Beaman Cemetery, and the Beaman Pond. Everything is gone now except the watering trough and the cemetery, though the Beaman name is by no means forgotten in town, with Beaman Street and the Beaman Library.

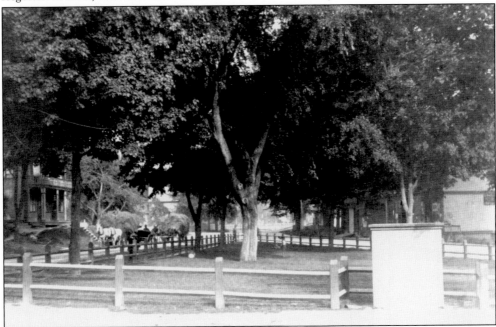

THE LOWER COMMON, THE PRE-RESERVOIR CENTER OF TOWN. The center of West Boylston was originally right where it is now. It moved to the lower common area (east of the north end of the causeway today) in the 1830s, following the development of industry around the meeting of the three rivers, and remained there until it was displaced by the reservoir.

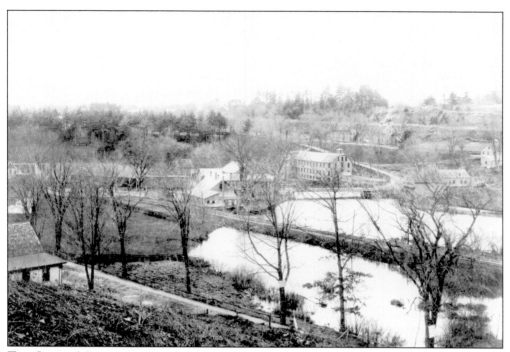

THE COWEE MILLS AND THE HOLBROOK MILLS. These two companies stood in an area now under water between the Old Stone Church and the railroad tracks. Cowee's grist mill is the jumble of buildings in the center. Holbrook's cotton mill is the big building to the right of them. From this angle the Old Stone Church would be just off the left side of the picture.

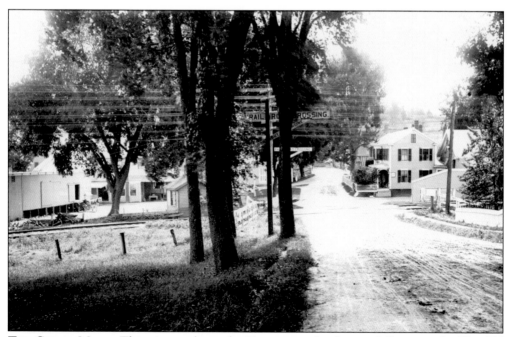

THE COWEE MILLS. This picture shows the Cowee complex from a different angle. The Old Stone Church was up the road beyond the houses on the right, hidden by the trees.

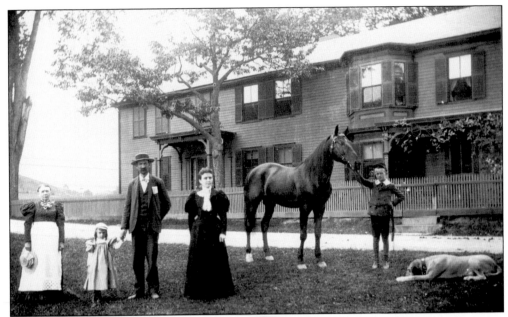

THE COWEE FAMILY IN FRONT OF THEIR HOUSE. The Cowee family lived right across the street from the mill, an arrangement not at all unusual for factory owners in West Boylston. Transportation was slow even if you were rich enough to have your own stable and carriages, so the trade-off between convenience and living in a good neighborhood was considered worthwhile.

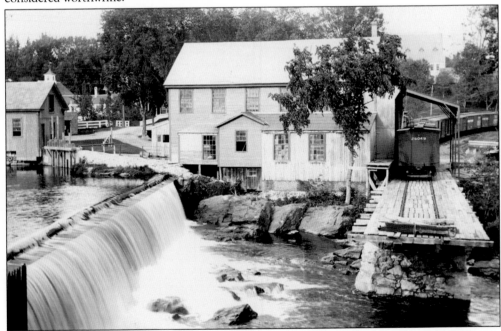

THE COWEE/HOLBROOK DAM. The two mills shared waterpower from the South Branch of the Nashua River. They were also served by a railroad spur, seen at the right. Before the reservoir, West Boylston had good rail service and provided the railroad companies with plenty of business.

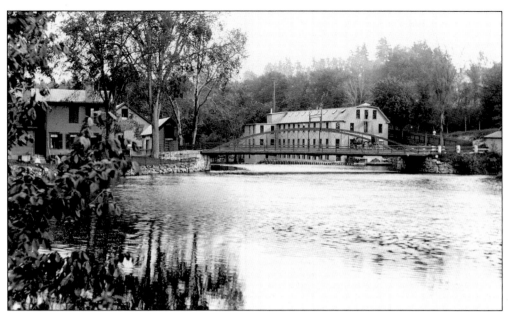

THE HOLBROOK MILL. Although clearly a factory town in the central area, West Boylston was still rural enough so that even the industrial sites could be a little scenic. The abundance of water showing in these factory pictures gives an idea of why the area was chosen for a reservoir.

THE HOLBROOK HOUSE. Once again we see the factory owner living near the mill. This impressive mansion was on Holbrook Street, which ran from around where the electrical towers are now, then parallel to the railroad tracks over to the Holbrook Mill. (Courtesy of the Beaman Memorial Library.)

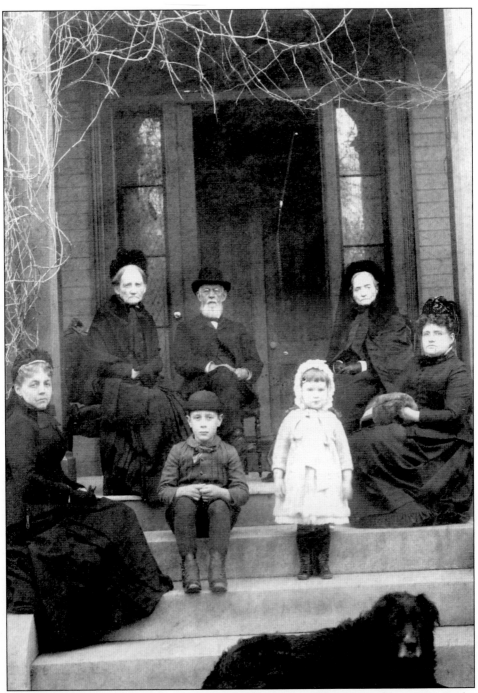

ELI W. HOLBROOK AND ADELINE WORCESTER HOLBROOK. Eli was brought to West Boylston as a child by his widowed mother, who managed a living by weaving at home. Eli started his career as a teenager working at the Beaman Mill, and by the time he was 34, he owned his own factory. He was to become one of the town's most prominent citizens. The cemetery chapel was built as a memorial to the Holbrooks. The street named for them, where their home stood, has now disappeared entirely.

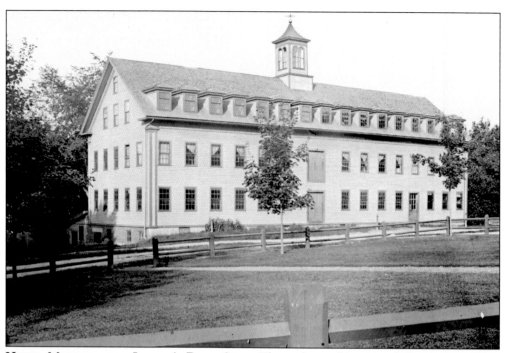

HOWE, MORTON, AND LOVELL'S BOOT SHOP. The making of boots and shoes was another important West Boylston industry. This factory stood right in the old center of town, across the road from the Brick Congregational Church, with a great tall chimney belching smoke. The concept of an industrial zone had not yet developed.

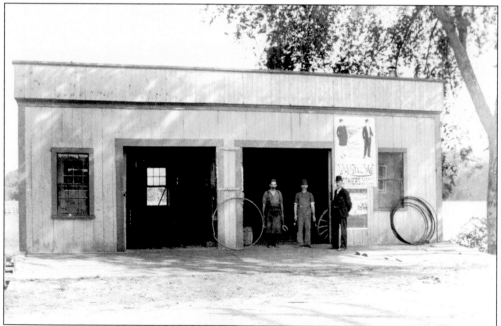

A BLACKSMITH SHOP. This would be one of several blacksmith shops in town, important to daily life during this time. The blacksmith not only kept the horses shod, but he maintained the carriages and wagons and did general repairs.

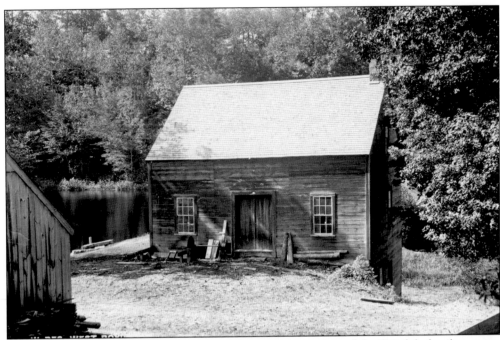

THE GOODALE ICE HOUSE. This was one of the many enterprises of the Goodale family, cutting ice from a pond and storing it for year-round use. The advertising card shows an interesting sideline. Since they needed to make excelsior to pack the ice, they also sold it for its other use—the packing of mattresses. Neither the refrigerator nor the innerspring mattress had come around yet. The icehouse was on Goodale Street.

Aaron Goodale,
DEALER AND CUTTER OF ICE.
CONNECTED WITH FARMING.
— ALSO —
MANUFACTURER OF EXCELSIOR
PUT UP IN BALES SUITABLE FOR A BED OR MATTRESS.

WARRANTED FREE FROM CHIPS AND DIRT AND NOT PRESSED SO HARD AS TO BE BROKEN.

WEST BOYLSTON, MASS.

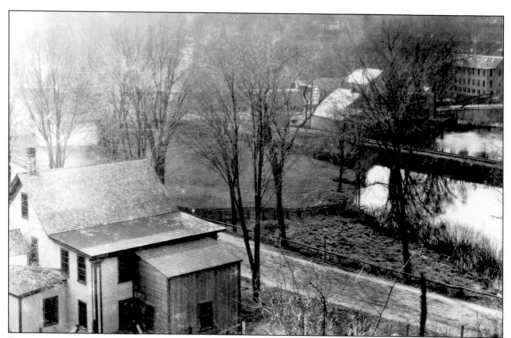

REED'S ORGAN SHOP. This was one of the few industries to survive the reservoir. George Reed bought a building called Sawyer Hall and moved it to Prospect Street, continuing to build organs there for some years after. The building is now Wayside Antiques. There is a rebuilt Reed organ still in use at Christ Lutheran Church.

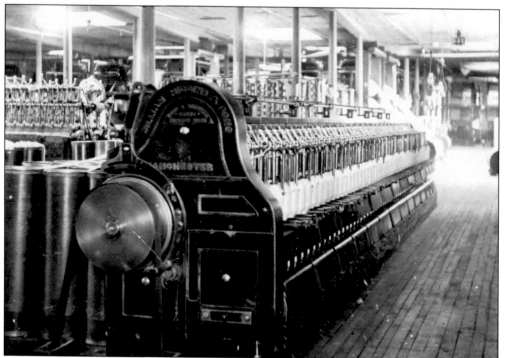

MILL MACHINERY. This is a rare picture of a mill interior. The machinery shown is for spinning.

THE WARFIELD MILL. Samuel Warfield built this factory in 1881 on the Quinapoxet River near the Holden line. He manufactured satinet warp and shoddy. Shoddy was a cheap cloth made from scraps of old clothes, the other fabric may have to remain a mystery, although it sounds a bit more upscale.

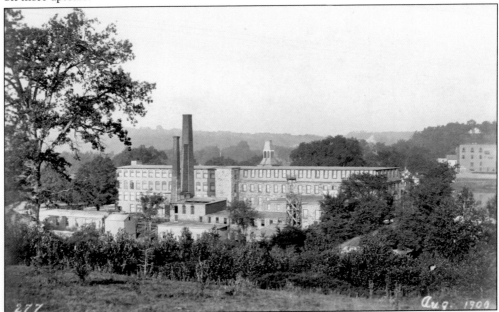

THE WEST BOYLSTON MANUFACTURING COMPANY. The mill property occupied a large part of the area below where the present Beaman Street meets North Main Street; the athletic fields, some of present-day Thomas Street, and River Road areas. It was the largest mill in town, originating in 1814. The mill owned 26 houses in the area. In 1863, along with several others, it came under the ownership of the Harris Brothers.

TWO VIEWS OF THE HARRIS MILLS. In 1845, Linus and Charles Harris bought a cotton yarn mill on the Quinapoxet River and added the weaving of cloth. In 1853, this mill burned and was replaced by a larger stone building, again to be replaced by the building shown here after a fire in 1874. By 1900, the operation had grown to 2 mills and 25 houses, and had become known as Harrisville.

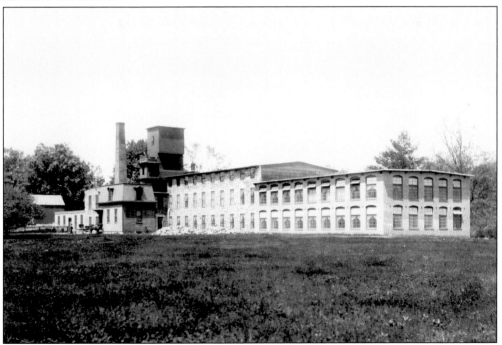

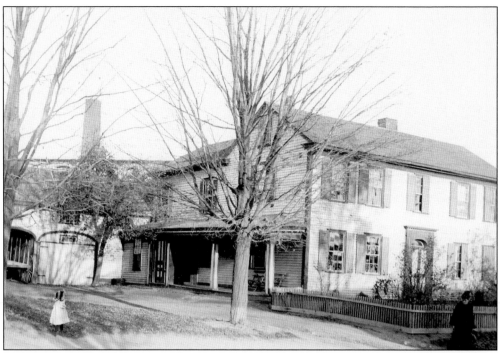

THE ROBERT BAILEY THOMAS HOUSE. Robert Bailey Thomas was not an industrialist, but rather the founder of *The Old Farmer's Almanac*. He built this house around 1810 in the area near the West Boylston Manufacturing Company. It is shown here as an example of how the town's leading citizens lived side by side with the mills. After his death in 1846, the Harrises bought it. Eventually, along with the mill, it was lost to the reservoir.

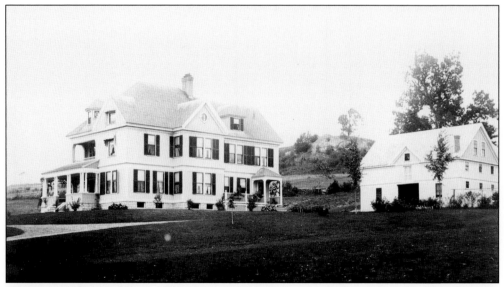

THE LINUS HARRIS HOUSE. This Queen Anne mansion, on the upper end of North Main Street, shows that by the late 19th century the mill owners felt less necessity to live next to the shop. Both Linus Harris and his brother Charles built their showplace homes in a better neighborhood. This one was far enough away from the water to survive the reservoir.

MARY HARRIS WHITING AND ALFRED WHITING. In the small social circle that West Boylston was, it was inevitable that there would be marriages among the industrialist's families. Mary Whiting was the sister of Linus and Charles Harris. Alfred Whiting ran the Whiting Mill shown on the following page.

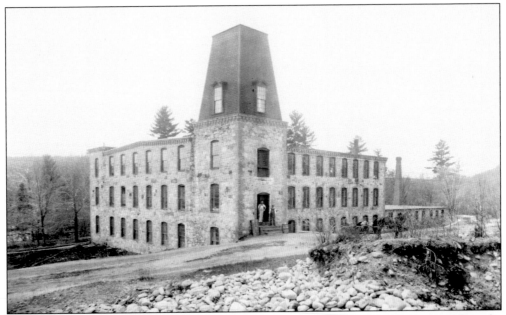

THE WHITING MILL. The mill was built in 1874 on the north side of the Quinapoxet River by the present rail trail. It manufactured light sheeting and shoe drills. The Harris brothers were associated with their brother-in-law in this enterprise.

THREE MILL MANAGERS. Mr. Lourie, Mr. Wakeside, and Mr. Lyons were photographed without any further identification. The conference, if that is what it was, looks important, if only because of the impressive appearance of the participants.

Three

THE COMING OF
THE RESERVOIR

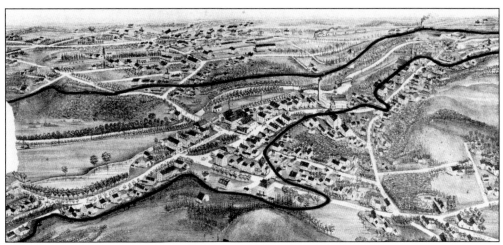

THE DESTROYED COMMUNITY. This pictorial map shows the town as it was around 1900, marked to show the area taken for the reservoir. Looking down from above, in the center is the Congregational church. The Old Stone Church and St. Anthony's are at the right toward the top.

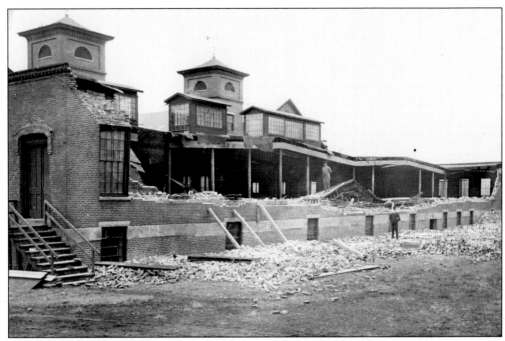

THE BEGINNING OF THE DESTRUCTION. The weaving room of the Clarendon Mills, the last of Ezra Beaman's empire, is shown being taken down.

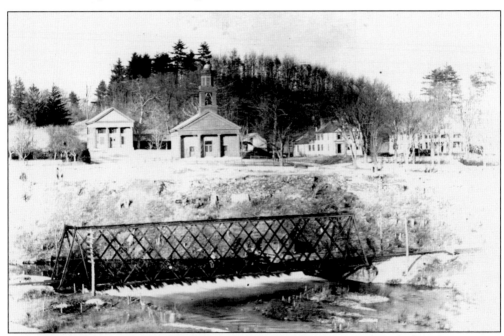

THE CENTER PARTIALLY DESTROYED. The Brick Congregational Church and Thomas Hall are still standing, as well as some of the houses, but everything across the street is gone. If this picture were taken today, Bob's Hot Dog Truck would be seen at the left. The land-taking process was spread over several years, with digging going on at the same time. Daily life in town must have been both depressing and frustrating.

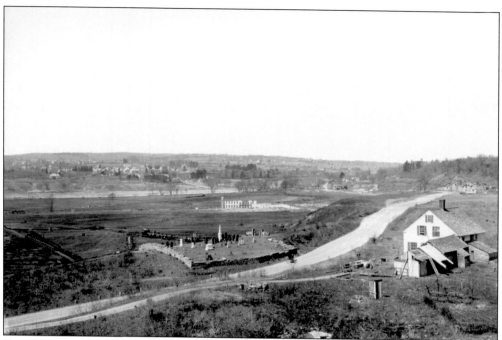

THE BEAMAN CEMETERY. The removal of the Beaman Cemetery to Mount Vernon Cemetery was one of the later operations, and this picture shows it with nothing left around it but one house and some of the mill buildings in the distance.

THE RUINS OF THE SAWYER HOUSE. This was on lower Prospect Street (now under water). The house was moved to Central Street, and the gazebo shown here was moved to the corner of Prospect and Scarlett. Both are still standing.

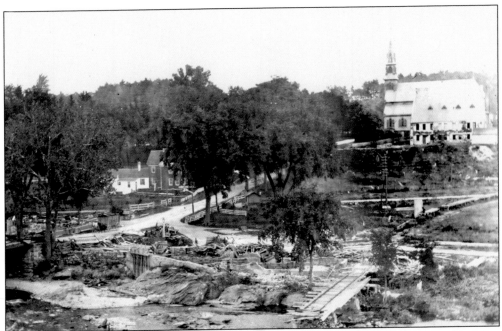

THE RESERVOIR AREA BEFORE THE WATERS CAME. Much of the demolition was done, but some buildings still remained. The Old Stone Church can be seen, along with St. Anthony's. The Cowee and Holbrook Mills, however, are gone, along with the dam that had stood between them. The railroad spur, shown in chapter two, is still there, but going nowhere.

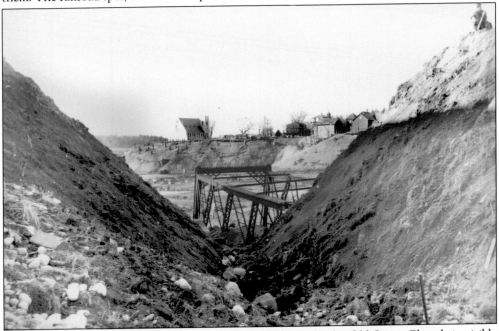

A VIEW FROM A DIFFERENT SPOT. In this later photograph, the Old Stone Church is visible distantly in the center, but St. Anthony's is gone. The railroad trestle is probably still under there. The state was careful not to leave any wood, which would pollute the water, but metal and stone were frequently left.

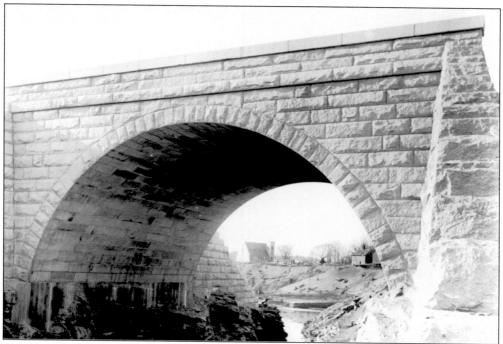

THE NEW CAUSEWAY. This appears to be taken from about the same spot as the previous picture, a while later. The causeway was opened to traffic on December 8, 1904.

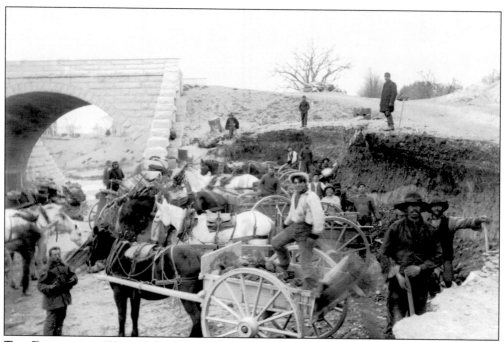

THE DIGGERS AT WORK. The labor and skill of the Italian construction workers was aided by "power equipment" consisting mostly of horses and mules. As well as digging the biggest man-made lake at that time, they had to build bridges and reconstruct the land and the roads.

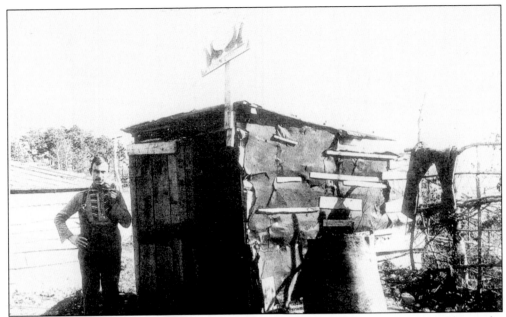

THE SHOEMAKER. The workers from Italy set up their own community services. This is the shoemaker's place of business; note the sign on top of the shack. Many of the workers remained in town after the job was over, sent home for wives, and became the ancestors of West Boylston's many Italian American families. (Courtesy of the Beaman Memorial Library.)

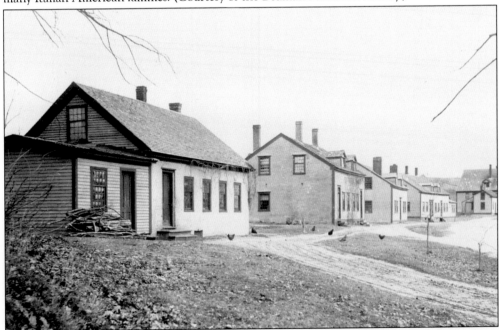

MILL HOUSING CONVERTED. As the mill workers left town, the empty tenements were put to use housing the construction workers. Here on French Hill on August 14 and 15, 1904, an Assumption Day festival was held, with religious services, an Italian band, Italian food, wine, and sporting events. They say that West Boylston never had seen anything like it before, nor has it since.

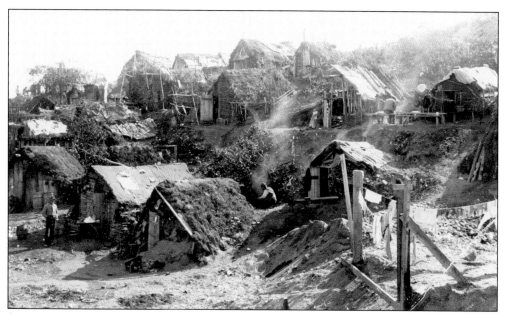

SHANTYTOWN. For some reason many of the Italian workers disliked the mill housing and preferred these shacks. It may have had something to do with independence—too much supervision by the bosses if you lived in the tenements. Certainly the shanties were not chosen for their luxury.

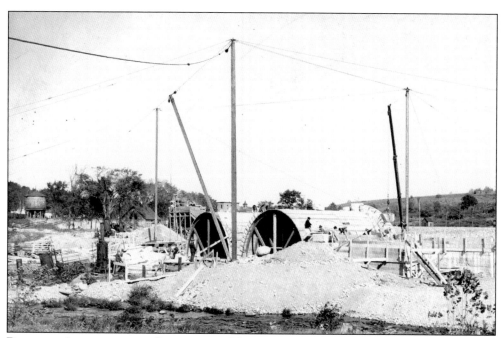

BUILDING ARCHES ON THE QUINAPOXET. The engineering was not entirely primitive, as these ingenious frameworks show.

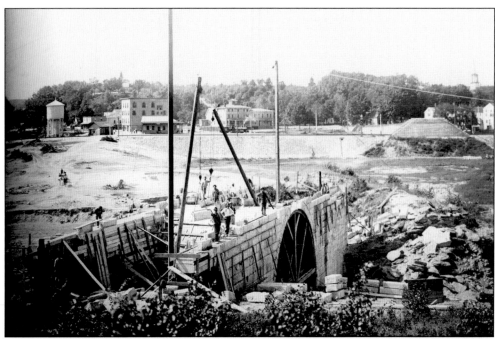

AN ARCH ON THE STILLWATER. This view shows an arch further along in construction. Oakdale can be seen in the background, with the church spire at the right. (Courtesy of the Beaman Memorial Library.)

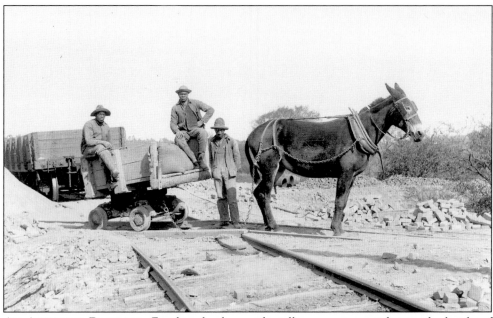

AN AUXILIARY RAILROAD. For short hauls, a mule pulling a cart on tracks was the height of technology. (Courtesy of the Beaman Memorial Library.)

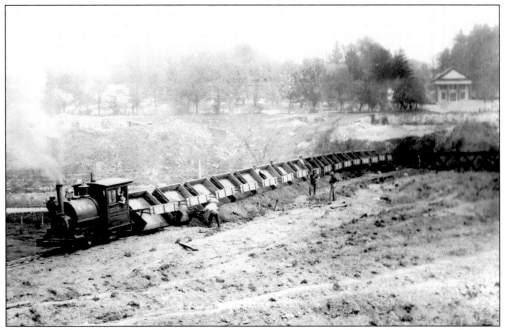

HAULING AWAY THE SOIL. There were some tasks that required more than horse and wagon capability. Fortunately, a little donkey engine like this could do a lot of earth moving. From the position of Thomas Hall at the upper right, it would appear that the train is heading in the direction of the Old Stone Church.

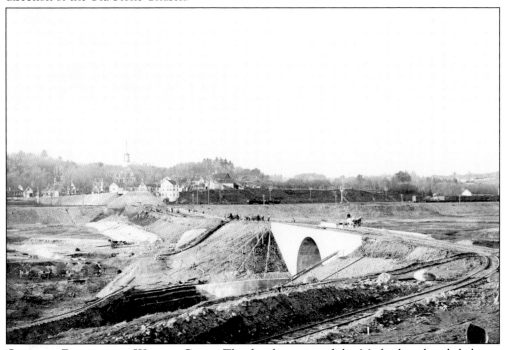

OAKDALE BEFORE THE WATERS CAME. The familiar spire of the Methodist church helps to identify this view, looking out along the present Beaman Street. Not only the water would be coming later, but also all the trees that would totally change the appearance of the area.

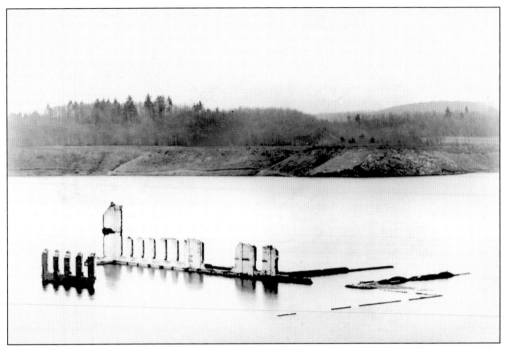

MILL RUINS. The best guess is that these ruins are from the Holbrook Mills. Most of the other sites, except for that of the Clarendon Mills, ended up in protected woods rather than under water.

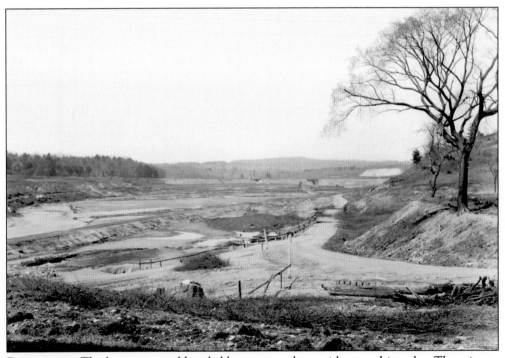

DESOLATION. The lone tree would probably go soon, along with everything else. There is not enough left in this scene to identify the location.

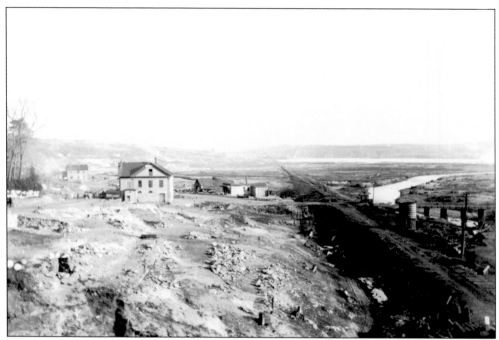

MORE DESOLATION. The few remaining buildings are probably deserted at this point, but the sorrow at losing homes, churches, and jobs must have been a great burden for those who stuck it out.

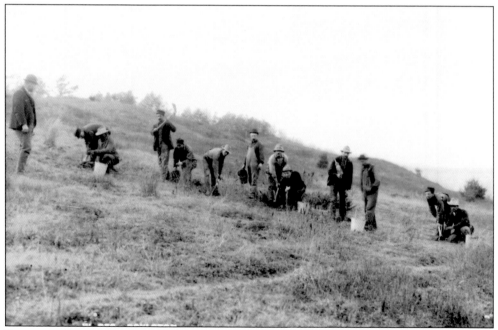

PLANTING WHITE PINES AND SUGAR MAPLES. The area surrounding the reservoir had to be reforested to protect the water. In late-19th-century Massachusetts towns, there was far less wooded land than there is today because so much territory was dedicated to farming. The state had to create new forests.

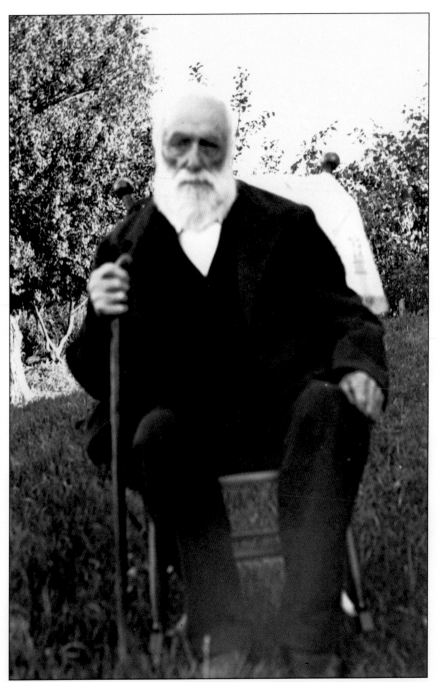

ASHLEY WOOD. In 1907, the reservoir was filled with water. Wood was 86 years old and thought to be on his deathbed. However, he was determined to see the great event and somehow managed to drag himself out of bed and walk down to the fill. The effort apparently did him a great deal of good, as he recovered his health and lived several years longer. He will be seen again in chapter seven in a group picture taken in 1911. He had a large farm on Wood Street and was a successful businessman and a selectman. As in many cases in town, the street took its name from the family who lived there.

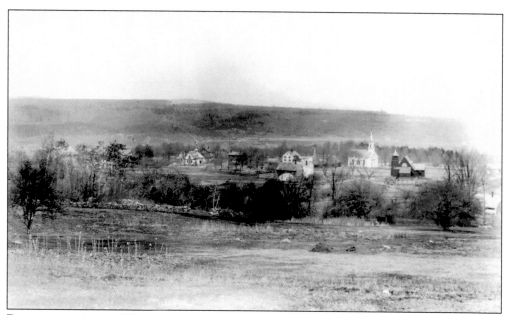

BEFORE AND AFTER. These two pictures show the present center of town from the hill where Wachusett Country Club is now. They would have been taken less than two years apart around 1902–1903. In the upper view, the little white Liberal church can be seen at the right, along with the new Baptist church. In the lower picture, the Liberal church is gone, replaced by the new Congregational church. The Odd Fellows Hall has been moved to its present site, and several of the new houses on Newton Street can now be seen.

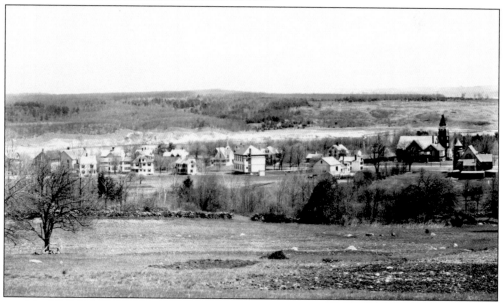

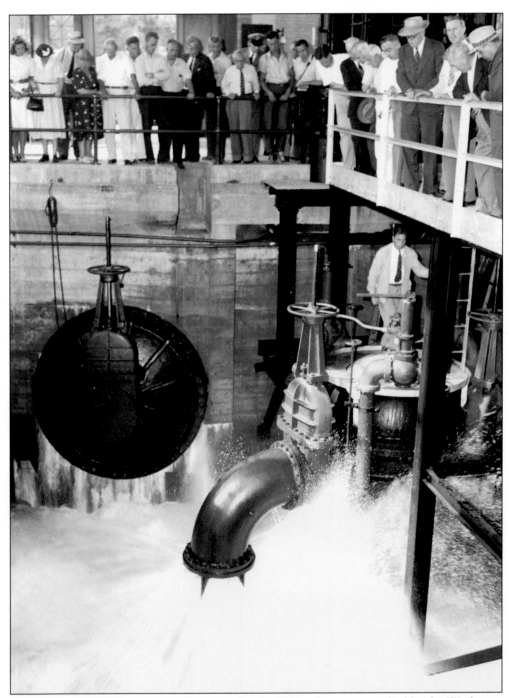

BRINGING IN THE WATER FROM QUABBIN. By the 1930s, the water supplied by the Wachusett Reservoir was no longer adequate for the Boston Metropolitan Area. A new larger reservoir, the Quabbin, was dug, wiping out several whole towns in the western part of the state. The Wachusett Reservoir became a halfway point for the water flow, and this picture shows the turning on of the giant tap to connect with the Quabbin. There are not many occasions when just turning on a faucet will draw a crowd.

Four

THE CHURCHES

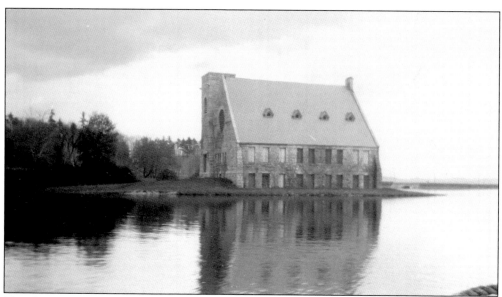

THE OLD STONE CHURCH, WEST BOYLSTON'S LANDMARK. The Old Stone Church was built in the early 1890s to replace the Baptist church which had been lost in a fire. Hardly 10 years later, it had to be abandoned for the reservoir. Because it was built of stone and was clearly going to be a scenic attraction visible from two main roads, the commonwealth was persuaded by townspeople to let it remain.

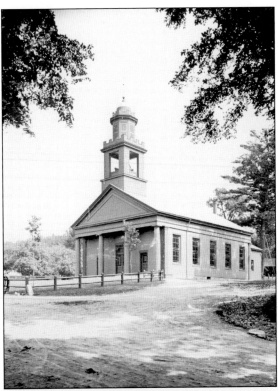

THE BRICK CHURCH. This was the second building of the Congregational church. The original meeting house burned in 1831, and the parish decided to move to the lower common (near the north end of the present causeway). This was the new part of town where industry was developing by the rivers. Years later, it would be destroyed because these same rivers provided an ideal site for a reservoir.

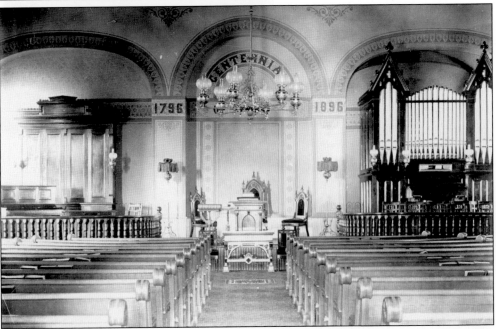

THE INTERIOR OF THE BRICK CHURCH. The church was extensively renovated in 1890, shortly before plans for the reservoir were announced. In 1903, the pews and many of the other furnishings were moved to the new building, which is the present church, although it was much changed by later renovations.

FANNY HAIR. Beginning in 1933, Fanny Hair was the organist at the Congregational church, after considerable experience in other area churches. She recognized the need for a new organ, and before she retired in 1945, she began to interest the parish in a drive to raise funds. The old organ, built for the Brick Church by the Reed Organ Company of West Boylston in 1875, was finally replaced in 1950.

THE REVEREND JOSEPH CROSS. He was pastor of the Congregational church from 1840 to 1860. He demanded an almost puritanical standard of conduct from his parishioners, with frequent excommunications and much ill will. He resigned in the midst of turmoil and scandal, left town, and returned after a while to live right next door to the church. In a complete reversal of character, he became one of West Boylston's most respected and beloved citizens. (Courtesy of the Beaman Memorial Library.)

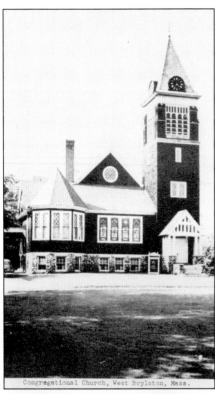

THE CONGREGATIONAL CHURCH. This church was built in Shingle/Queen Anne style in 1903 to replace the Brick Church. The general shape can still be recognized, but in the 1960s it was encased in brick to give it a Colonial–style appearance. This site is precisely where Ezra Beaman's original meeting house stood before it burned.

Congregational Church, West Boylston, Mass.

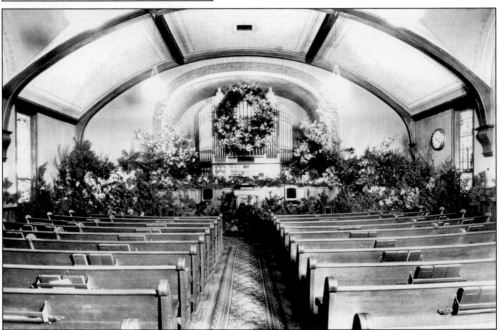

THE INTERIOR OF THE CONGREGATIONAL CHURCH. This picture from the early 20th century shows the pews from the Brick Church. The beams in the ceiling are still there, but everything else is changed now. The clock on the right appears to be the same clock that is at the back of the church today. It came from Thomas Hall, which stood next to the Brick Church.

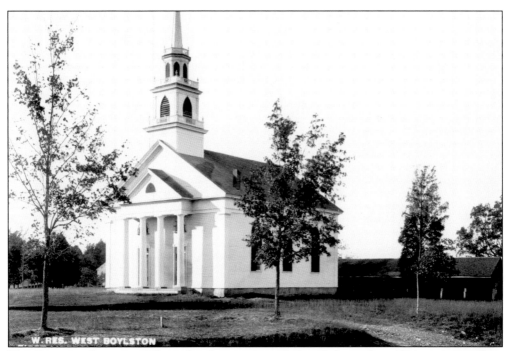

THE LIBERAL CHURCH. When the Congregational church burned in 1831, some members who were inclined toward Unitarianism built this church on the common. It never grew much and never had a permanent pastor. When the reservoir came, the site was given back to the Congregationalists.

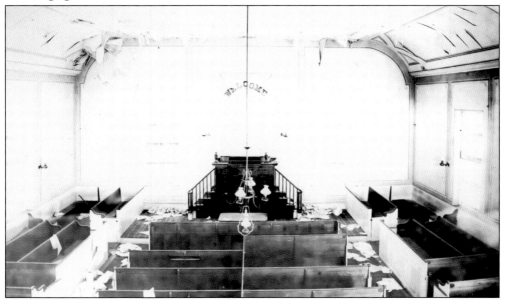

THE INTERIOR OF THE LIBERAL CHURCH. The picture shows the church just before it was torn down. At first it was thought that the Congregationalists might use it, but the building was clearly too small. A few of the remaining members objected to its destruction and refused to sell their pews. A legal struggle went on for awhile, but was finally settled and the new church was built.

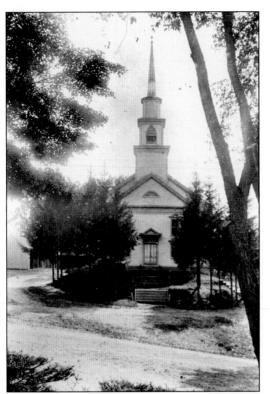

THE SECOND BUILDING OF THE BAPTIST CHURCH. This Baptist church stood where the Old Stone Church is today. The building burned along with its neighbor, St. Anthony's, in 1890. No pictures of that St. Anthony's are known to exist, nor are there any pictures of the Baptists' first church, which was in Oakdale. The Baptists had been in West Boylston since 1818.

THE REVEREND GEORGE DARROW. Reverend Darrow was pastor of the Baptist church for three different periods between 1856 and 1887. In his day, the Baptists usually performed baptisms outdoors in a pond or one of the rivers, sometimes having to break ice to do it in the winter.

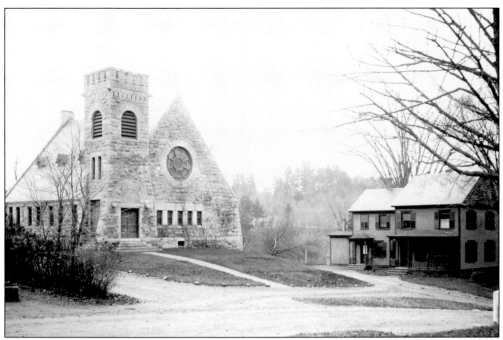

THE OLD STONE CHURCH. This shows the building as it was during its brief span as an active church. It was on a busy street with buildings on both sides. The parsonage next to it was moved when the new church was built in 1902 and is still standing on Church Street.

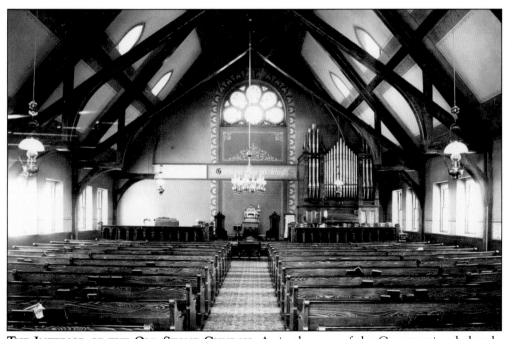

THE INTERIOR OF THE OLD STONE CHURCH. As in the case of the Congregational church, most of the furnishings, including the stained glass windows, were moved to the new building on Church Street. St. Anthony's Church did the same thing when it moved to its new church in Oakdale.

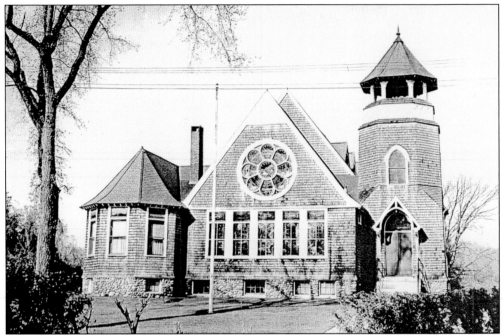

THE NEW BAPTIST CHURCH. The new Baptist church was roughly the same size and shape as the Old Stone Church so that everything would fit. It gave Church Street its name. The Baptist church was closed in 1971, and the building is now the Masonic temple. The building still looks the same, except that the shingled exterior has been changed.

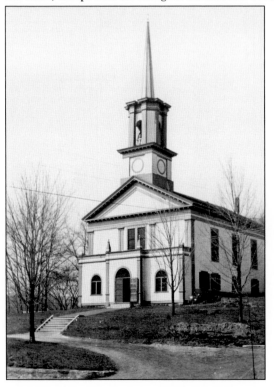

THE METHODIST CHURCH IN OAKDALE. Methodism in West Boylston goes back to 1841, and the church was built in 1858. The reservoir stopped short of the church by a block or two, so this is the only old church in town still in its original building on its original site. The architecture is an interesting blend of the Greek Revival and Italianate styles.

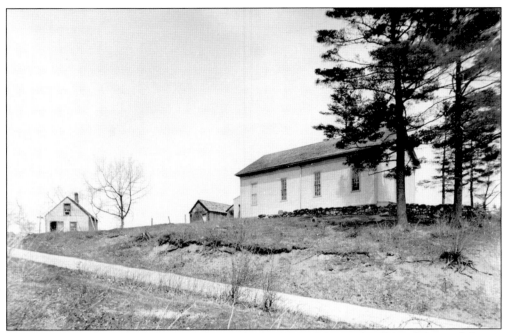

ST. LUKE'S CHAPEL. This little church was the ancestor of Our Lady of Good Counsel. It was built in 1854 to serve the French Canadian and Irish families who came to West Boylston to work in the thriving industries. The church stood on a hill between the old Beaman Street and Union Street, a little to the east opposite where Holt Street begins today.

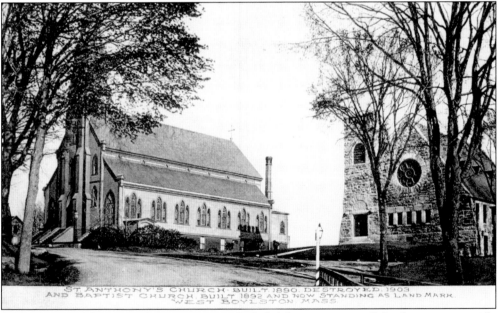

ST. ANTHONY'S CHURCH. As time went on, St. Luke's became too small for the growing parish, and a new church was built next to the Baptist church. When the churches burned in 1890, they were rebuilt on the same sites. When the reservoir came, the stone Baptist church was allowed to remain, but St. Anthony's, built of wood, had to go. All wood was removed from the area to avoid pollution.

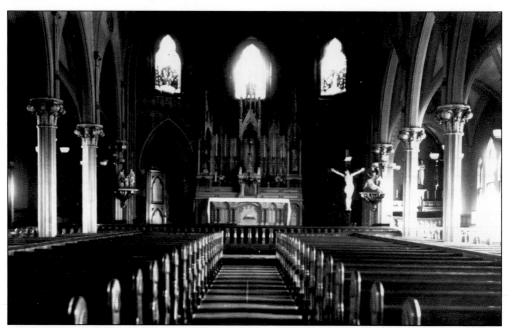

THE INTERIOR OF ST. ANTHONY'S. It is hard to imagine this striking example of a large High Victorian Gothic church in West Boylston, but this was a sizable and prosperous parish until the reservoir took away most of the jobs of its parishioners, many of whom were forced to leave town to find work.

ST. ANTHONY'S RECTORY. The two churches stood side by side, with homes for their clergy next to each. Remarkably three out of the four buildings still survive. This house was moved to Crescent Street. The picture, showing part of St. Anthony's Church on the right and the barn and house on the left, gives an idea of what this part of town was like before it became only a scenic view.

OUR LADY OF GOOD COUNSEL IN OAKDALE. Apparently the parish felt it was time for another name change. The church to replace St. Anthony's was built, like the others, in roughly the same size and shape to accommodate the transferred furnishings. It stood near the entrance to High Plains Cemetery. It took many years to recover its membership, but eventually it was replaced by the present church in the center of town.

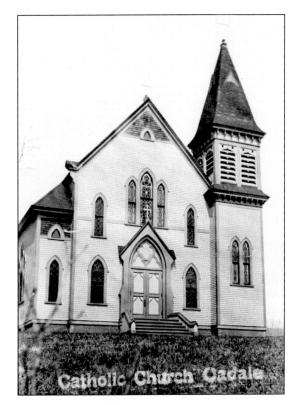

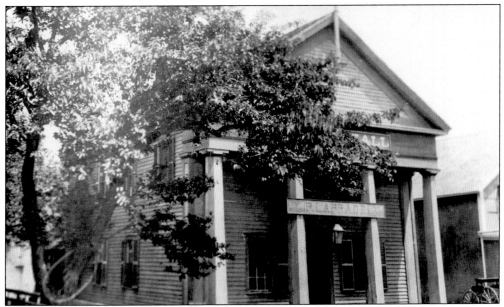

FREEDOM HALL. This little building on Harris Street in Oakdale was built at the direction of the heirs of William Thomas, Robert B. Thomas's father, and designated as a place of public worship open to all denominations. The Methodists worshipped here until they built their own church in 1858, and other churches used it from time to time. Harris Street was in the area at the lower end of Oakdale, now park land.

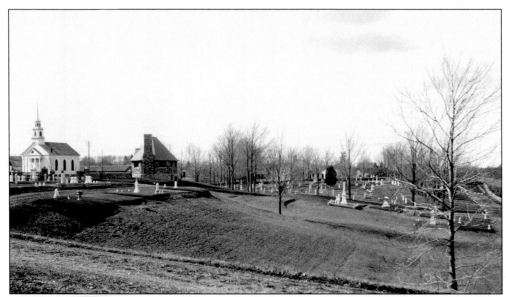

THE LIBERAL CHURCH AND THE CEMETERY. The little white church would be torn down soon after this picture was taken, and the Congregational church would return to this spot. The cemetery was much smaller then, as shown by this picture, which was probably taken from a spot behind the present site of Our Lady of Good Counsel. The other building is the new cemetery chapel, built on the site of the former town pound and hearse house.

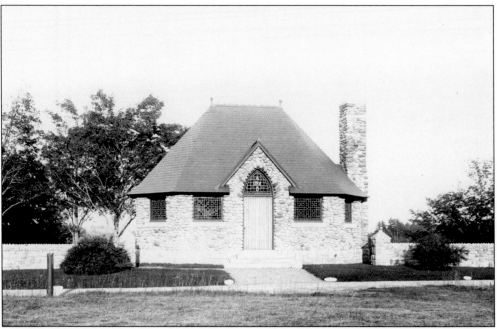

THE HOLBROOK CHAPEL. The chapel was built in 1891, as a memorial to Eli Holbrook, a local mill owner, and his wife Adeline, as well as to William Nash, the first minister in town, and his wife Elizabeth, by their descendants. It is the only stone Gothic building in West Boylston. The chapel is still used occasionally for small funerals and has a beautiful interior, which has been carefully maintained.

Five

CELEBRATIONS AND EVENTS

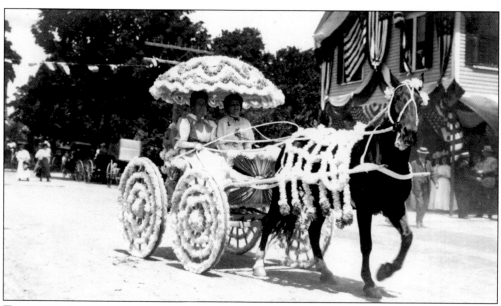

THE 1908 CENTENNIAL PARADE. The town was celebrating the 100th anniversary of its incorporation, and this lavishly decorated carriage was typical of the entries in the parade. The ladies are Helen Mixter (left, driving), and Mrs. Myron Potter. Mixter was a highly respected teacher for whom the Mixter School, later the municipal office building, was named.

THE CENTENNIAL CELEBRATION PROGRAM. It should be remembered that although West Boylston was only 100 years old as a chartered town, it had a separate identity as "the Second Precinct of Boylston, Holden and Sterling" since 1796 and had been a settled community going back to the 1720s.

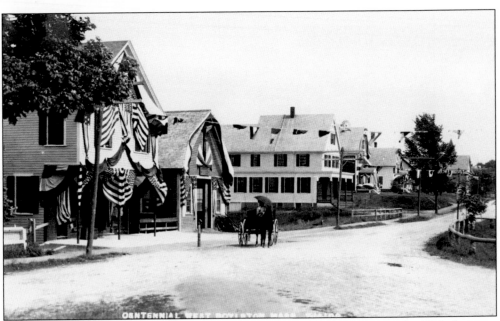

SAWYER'S STORE ON CENTRAL STREET DECORATED FOR THE CENTENNIAL. In 1908, the town was only just recovering from the trauma of the reservoir, and the people seemed to want to go all out in decorating and celebrating. Perhaps this was a way of telling the world that they had survived.

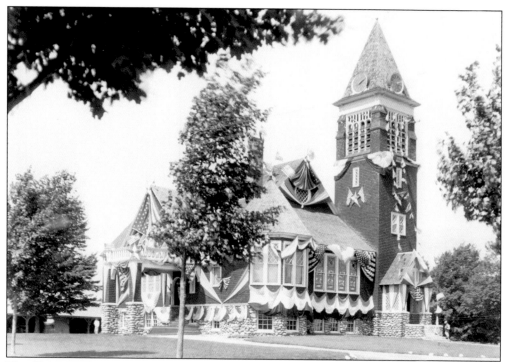

THE CONGREGATIONAL CHURCH. Restraint was not a characteristic of the style of decoration. But the church had a right to celebrate, as it was its founding that led to the creation of the precinct that became the town.

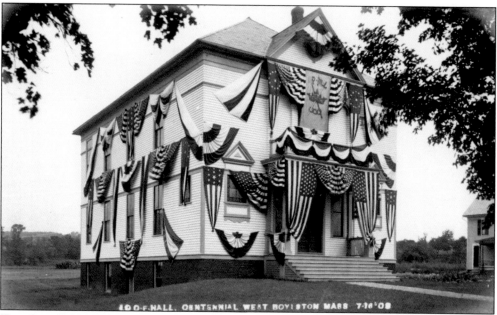

THE ODD FELLOWS HALL. It would appear that the lodge did not want to be outdone by the church across the street. This building, unlike the church, has not changed much over the years, but the surroundings have, with the addition of the lodge's parking lot and a whole block of houses behind it on Scarlett Street.

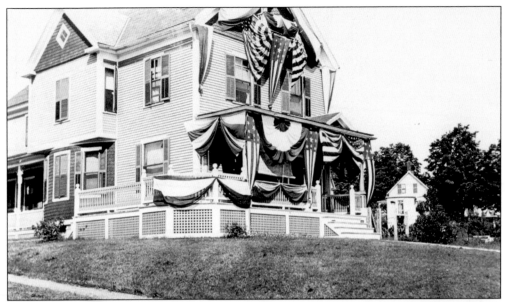

A DECORATED HOUSE. In 1908, private homes were not satisfied with just putting out a flag. It must have been an exciting experience to walk around town in this sea of red, white, and blue.

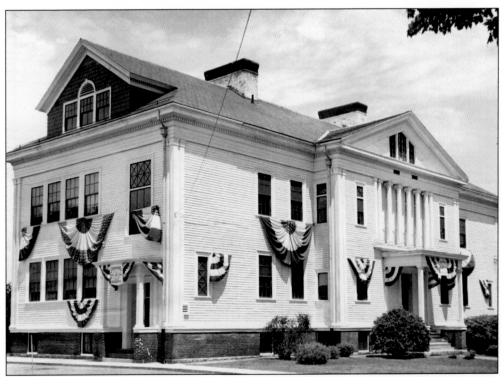

THE GOODALE SCHOOL. The display is a little quieter here. The bunting dealers may have been running low. The Goodale School had been recently built to replace a number of small schoolhouses. It stood, until 1982, where Pride Park is now. Generations of West Boylston residents remember it fondly.

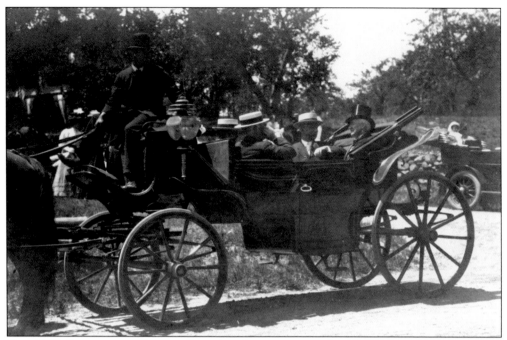

THE 1908 CENTENNIAL PARADE. Seated in the carriage are, from left to right, chairman of the board of selectmen Aaron Goodale, Hon. John R. Thayer, Congressman Charles E. Washburn, and Mayor James Logan of Worcester.

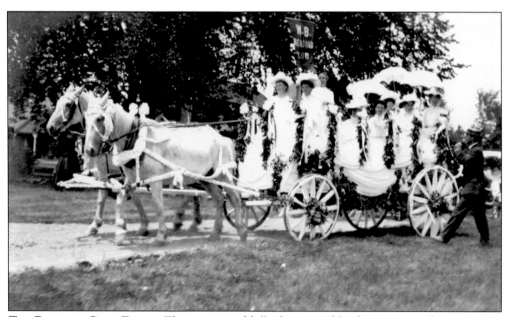

THE READING CLUB ENTRY. The costume of frilly dresses and big hats was popular, as was the practice of loading as many people as possible on the carriage.

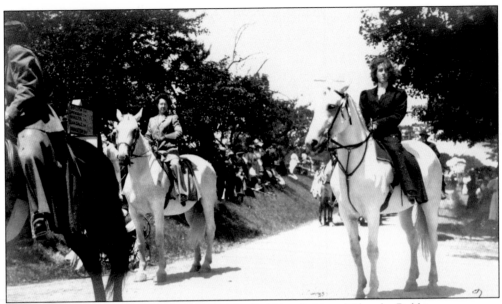

EQUESTRIENNES. On the white horses are May Robbins (left) and Blanche Robbins.

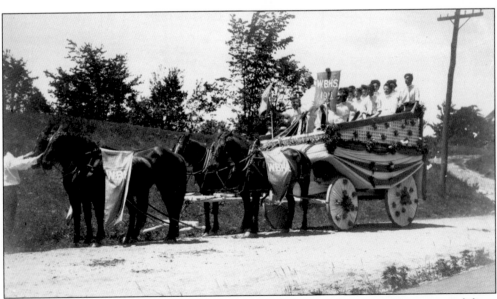

THE HIGH SCHOOL'S ENTRY. Again we see the crowded wagon, but this younger group did not go for the hats. This picture appears to have been taken on Crescent Street near Prospect Street. (Courtesy of Aaron Goodale.)

100th ANNIVERSARY

The Town of West Boylston

Will commemorate its
one hundredth birthday

THURS. JAN. 30
1908
At the Town Hall

A Program has been arranged for Afternoon and Evening.

AFTERNOON at 2 P. M.

The exercises for the afternoon will consist of a
Concert by the 9th REGT. ORCHESTRA, of Boston
Speeches by the Hon. JOHN R. THAYER, Justice
ARTHUR P. RUGG, and former citizens of the town
Selections will be rendered by prominent soloists
The High School will also take part in the musical
program
ALL INTERESTED ARE INVITED TO BE PRESENT.

EVENING at 8 P. M.

GRAND CENTENNIAL BALL

Music: 9th Regt. Orchestra of Boston, **eight pieces**

W. B. WOOD - - FLOOR DIRECTOR

AIDS:

Daniel A. Lynch	William E. Storms	Carleton A. Cook	Arthur Ward	William J. McGinnis
Walter E. Chapman	Myron D. Potter	Joseph H. Cavanaugh	Dr. H. W. Trask	H. Fay Baldwin

RECEPTION COMMITTEE:

Frank H. Baldwin	John S. Lynch	W. Clifford Scarlett	Parker M. Banning
	D. Frank Prescott	Charles C. Landy	D. Clifford Lord

CONCERT, 8 to 9. DANCING, 9 to 1.

THE CENTENNIAL POSTER. This marvel of early-20th-century graphics announced the many events. (Courtesy of Aaron Goodale & Dennis Parker.)

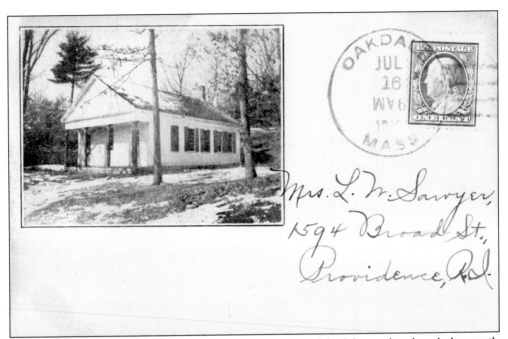

THE SPOONWOOD SCHOOL REUNION, 1912. The school had been closed and the pupils transferred. The building then became a public hall and this postcard announced a reunion. The Spoonwood Schoolhouse still stands on Laurel Street, now a private home. The name comes from the spoonwood tree, a synonym for laurel.

Oakdale, July 8, '12.

DEAR FRIEND:

The old "Spoonwoods School" which we attended as children has been changed into a hall. To make a Red Letter Day in its history it has been decided to have a reunion Saturday afternoon and evening, August 3d and to invite everyone who has ever attended this school.

Will you and your friends not come to help us form an Alumni Association that we may meet and have a pleasant day each year? The dues will be but fifty cents. The committee desires you to extend this invitation to anyone who you know attended this school.

Kindly reply as soon as possible and send membership fee to anyone of the committee. Come whether you wish to join or not.

Light refreshments will be served in the afternoon and during the intermission of the dances in the evening.

COMMITTEE,

THEOBALD A. LYNCH,	JESSIE RICE JORDAN,
M. PARKER BANNING,	MARY E. WILSON,
GEORGE M. LAWRENCE,	BERTHA L. BOSWORTH.

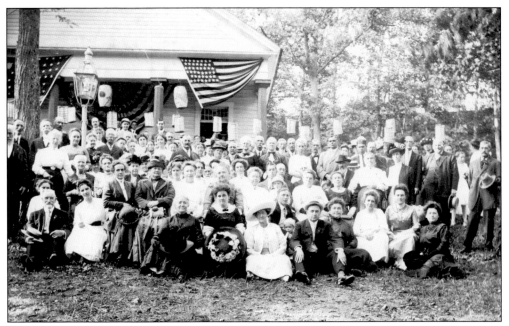

THE REUNION. The postcard brought a good turnout. It is not known if the annual meetings continued, but this group looks as if they were enjoying themselves enough, in the quiet way of their time, to come back next year. The 46-star flags make an interesting sidelight. They would become obsolete that year with the admission of two new states.

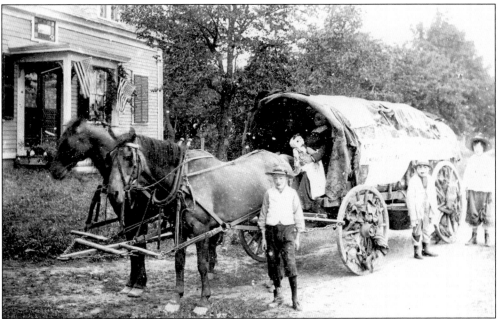

THE HORRIBLES PARADE. This event is definitely not part of the 100th anniversary celebration. These fun parades were held on the night before the Fourth of July for many years and were accompanied by all the foolishness people could think up. Standing, from left to right, are Clayton and Roland Parker and Chester Smith. The driver, out of sight, is John Smith and Bill Sabin holds the baby.

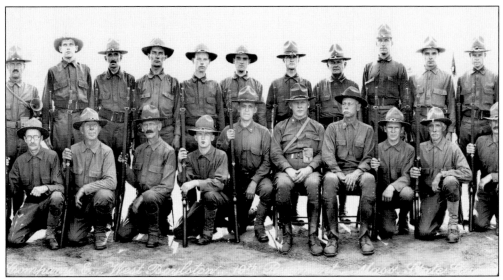

TWO MILITARY EVENTS FROM WORLD WAR I. In the upper picture, West Boylston's Company E, Massachusetts State Guard poses for an official photograph. The state guard was organized to protect the home front in the absence of the National Guard and consisted of men ineligible for the army but willing to serve. In the lower picture they are shown drilling outside the Oakdale Methodist Church.

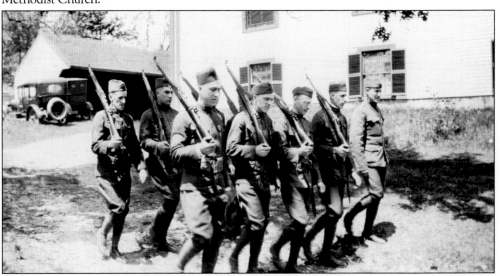

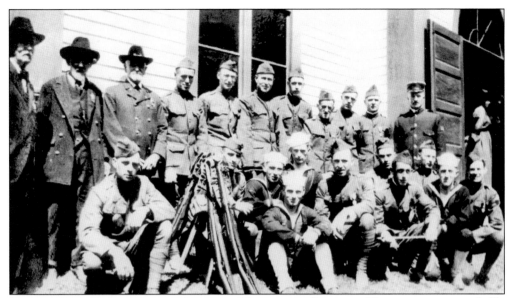

VETERANS IN FRONT OF THE OAKDALE METHODIST CHURCH. The picture was probably taken shortly after World War I. The veterans are, from left to right, as follows: (first row) four unidentified, Clarence Phelps, Chester Denton, three unidentified, Dwight Goodale, and unidentified; (second row) George Blunt, Levi Shepard from Princeton, Charles Huntley, Ernest Oatway, Ralph Whitcomb, Frank Luce, two unidentified, Clifford Burlingame, Harry Silvester, and unidentified.

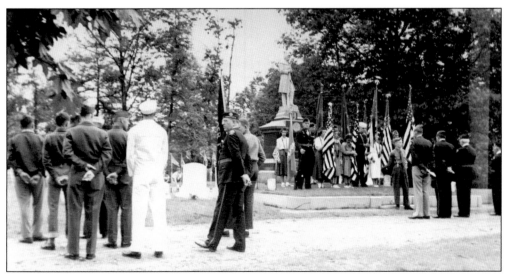

A MEMORIAL DAY PARADE. West Boylston always has a dignified and moving observance of Memorial Day, a tradition that continues into the 21st century. This picture of the ceremonies at the Civil War monument dates from the 1950s.

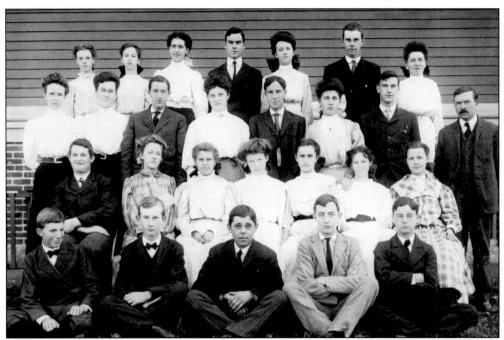

A Class at the High School, 1907. All dressed up in their Sunday best, these students pose in front of the Goodale Street School where the high school shared space with the lower grades. Their teacher was Edgar Neal (standing apart on the far right).

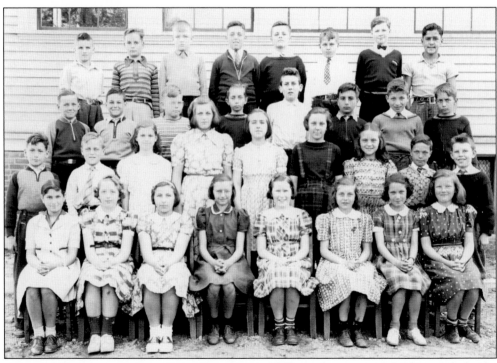

Another Class in the Same Spot. Years later in 1939, another group of children smile for the camera. No longer the High School, it is officially called the Goodale Street Grammar School.

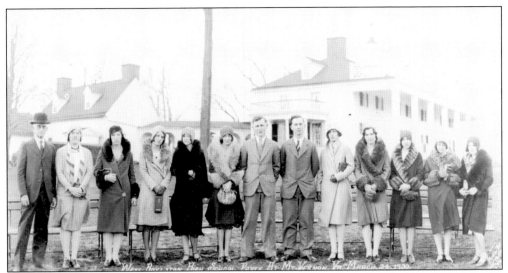

THE HIGH SCHOOL'S SENIOR TRIP, 1930. Just as it is today, Washington was a popular destination for class trips. This photograph was taken at Mount Vernon. The boys probably did not complain about being outnumbered ten to two by the girls.

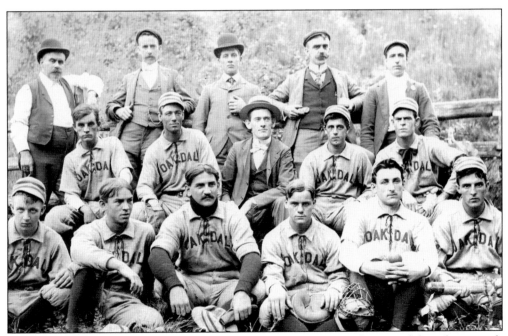

THE OAKDALE BASEBALL TEAM. This picture was taken in 1899. The team did not have much depth on the bench, but there seems to have been a large coaching staff.

"OLD FOLKS' CONCERT." The Congregational church held this event as part of the celebration of the church's 150th anniversary in 1946.

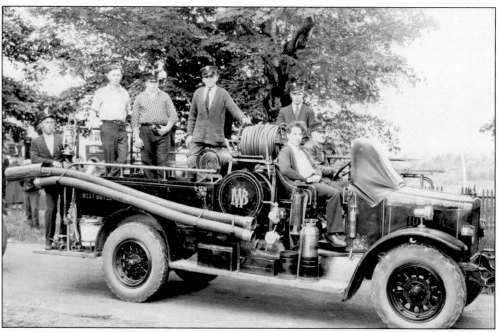

THE WEST BOYLSTON FIRE DEPARTMENT. The individuals shown here are probably lining up for a parade. Pictured are, from left to right (standing) Bill Suffill, Evan Luce, Fred Brown, unidentified, and Warren Reed. Seated in the truck are Nan Bonci and Ernest Burpee in the driver's seat.

A Scene from the Independence Day Parade, 1949. In the past West Boylston was known for its Fourth of July celebrations. Along with the parades, the fireworks displays at Goodale Park drew people from miles away.

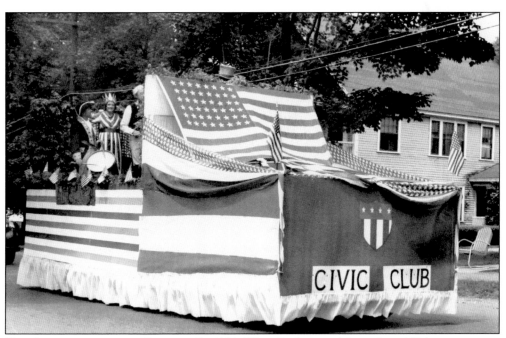

The Sesquicentennial Parade. In 1958, West Boylston celebrated its 150th anniversary. This patriotic float was sponsored by the Civic Club, a very active group in town at the time.

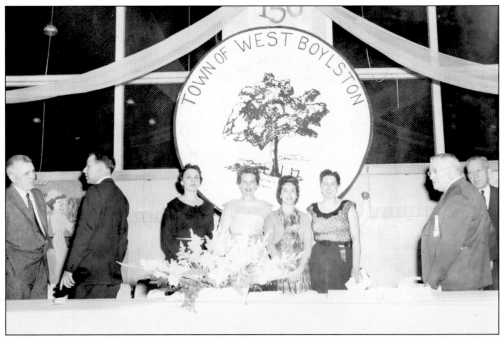

MORE OF THE 150TH ANNIVERSARY CELEBRATION. We can recognize a few of this head table group. From left to right they are unidentified, Jack Bryce, unidentified, Doris Chartier, unidentified, Mildred Mulroy, Julius Lovell, and unidentified. (Courtesy of James Mulroy.)

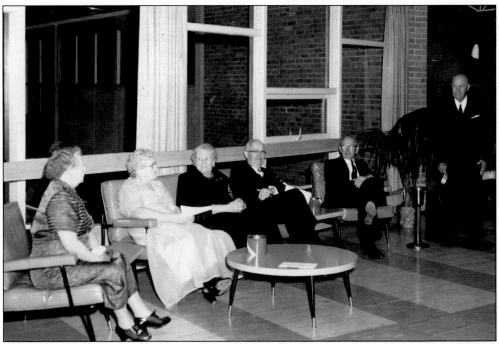

ANOTHER GROUP AT THE 150TH ANNIVERSARY PARTY. In the center, third and fourth from the left, are Lily and Raymond Huntington. He was the well-liked mayor of Oakdale. On the far right is Calvin Brackett. (Courtesy of James Mulroy.)

Six

OAKDALE

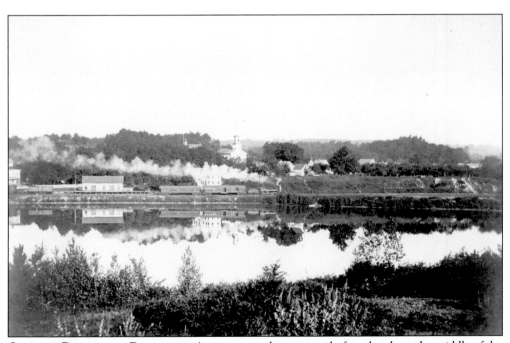

OAKDALE BEFORE THE RESERVOIR. A steam train leaves a trail of smoke along the middle of the picture. The Methodist church provides a recognizable landmark in the center. The water in the foreground is the Stillwater River and its glassy, calm surface shows how it got its name.

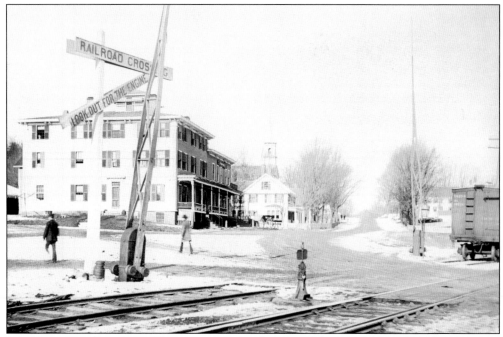

THE RAILROAD CROSSING. This spot is now in the area of the ball fields and the beginning of the rail trail.

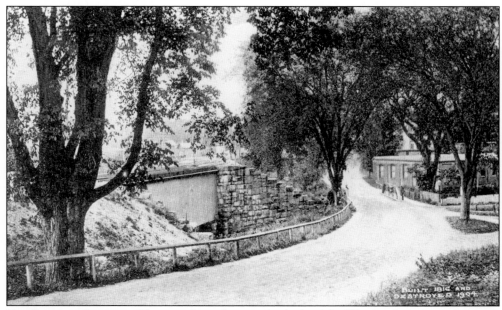

THE ROAD TO OAKDALE. The spot shown here, with a little of the West Boylston Manufacturing Company at the right, is just south of the previous picture.

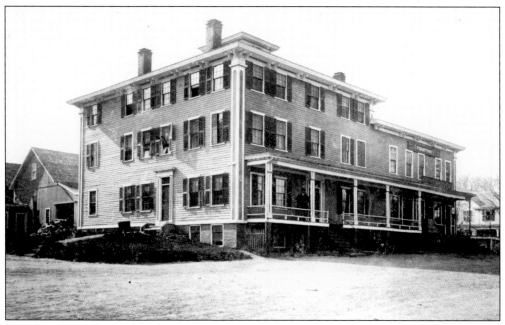

THE OAKDALE HOTEL. Until it was torn down for the reservoir, the Oakdale Hotel stood just below where the first houses on the left of North Main Street are now. At one time, it was one of the many enterprises of the Harris Brothers.

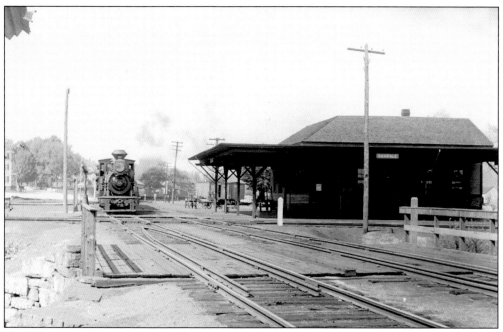

THE OAKDALE DEPOT. This station survived the reservoir and operated well into the 20th century. It was torn down in the 1960s.

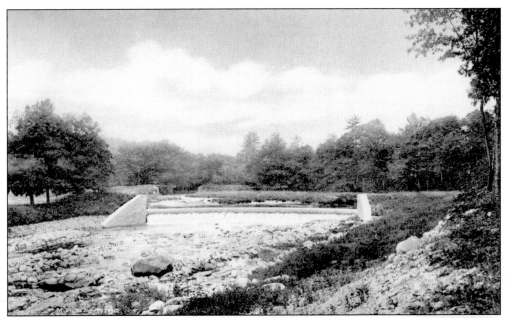

TWO SCENES ALONG THE QUINAPOXET RIVER. The upper picture shows the Horseshoe Dam. One of the positive aspects of the reservoir was that it preserved beautiful wooded areas like these, still to be enjoyed along the rail trail.

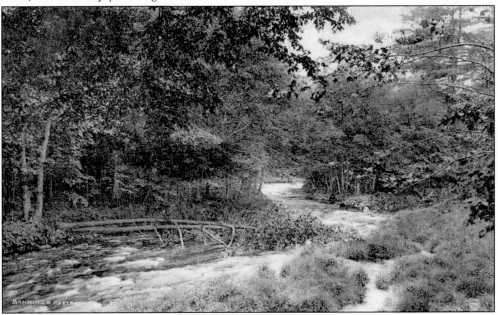

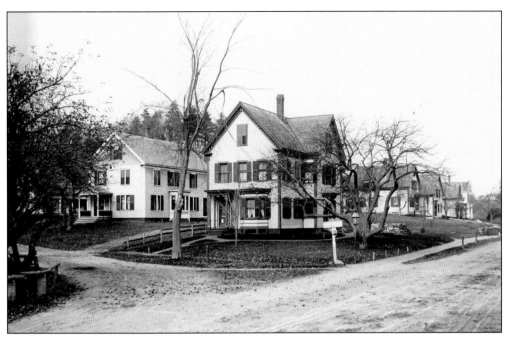

THE CORNER OF NORTH MAIN AND LAUREL STREETS. This view from around 1900 is remarkable in that it shows how little has changed. These houses are typical of the Greek Revival style of the period, between 1829 and 1860, that dominates Oakdale's architecture and gives the village its charm.

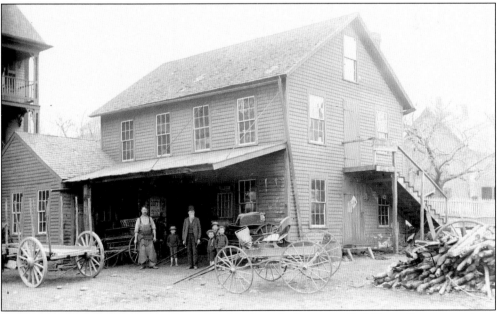

LOVELL LESURE'S BLACKSMITH SHOP. The blacksmith shop was off of Harris Street, just above where the rail trail begins now. From 1845 until about 1895, Lesure provided a service that all villages required in earlier days. It was like a combination of today's car repair shops and machine shops. The smith would build and repair buggies, shoe the horses, and make tools and farm implements for the villagers and the mills.

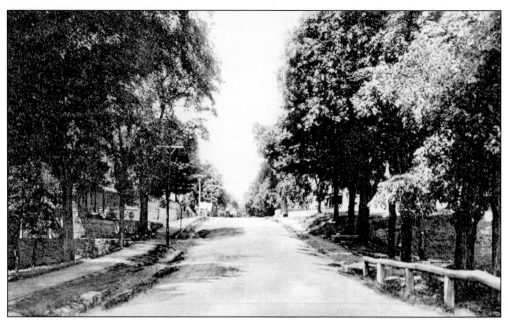

NORTH MAIN STREET. This old picture shows the changes that have taken place. The road is widened and paved now, and there are fewer trees. However, if you could see the houses behind those trees, you would see little change. Oakdale is the best-preserved part of West Boylston and has been designated a historical district.

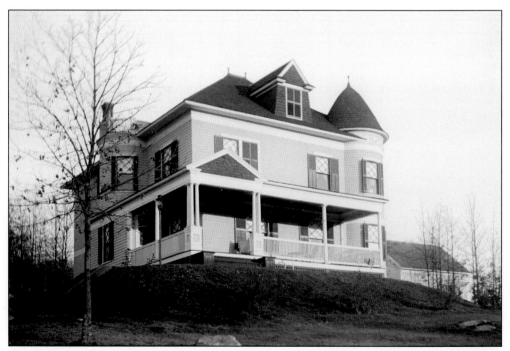

THE CHARLES HARRIS HOUSE. This is a companion to his brother Linus's house, seen in chapter two. Unfortunately this one was too near the water and was destroyed. It stood near the Training School in the area near the present Beaman Street.

JOEL WALKER. Born in 1798, Joel Walker lived just shy of 98 years. A farmer in early life, he made his fortune by buying and selling farms and residences. He and his wife Daedamia were the parents of a large family, and he left his daughters substantial investments as well as the heritage of longevity, as two of them lived into their 90s and one reached 100.

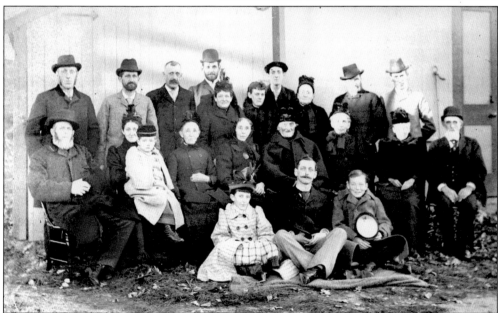

THE WALKER FAMILY AT THANKSGIVING. In 1892, the holiday was much as it is today—the perfect time for a group photograph. This picture shows Joel Walker in the second row center with three of his daughters and his extended family, which includes Goodales, Merriams, and other prominent West Boylston names. The Walkers were active in the Baptist church and donated the bell and the reed organ. (Courtesy of Barbara LaComfora.)

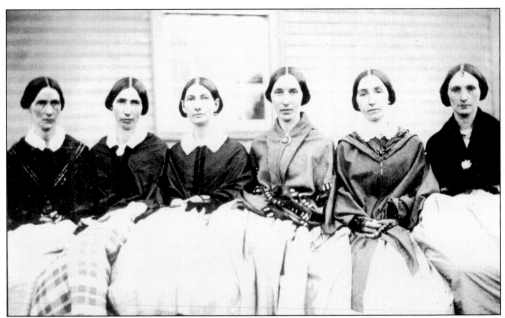

THE SIX DAUGHTERS OF JOEL AND DAEDAMIA WALKER. The picture was taken at Oakdale Depot in 1860. The sisters are, from left to right, Miriam, 1824–1861, who married Windsor White; Emily, 1826–1926, who married William Parker; Louisa, 1828–1889, who married Hubbard Hurd; Alona, 1830–1921, who married Albert Hinds; Lucy, 1832–1927, who married Francis Merriam; Martha, dates unknown, who married Daniel Holbrook.

ALONA WALKER HINDS. Three of the sisters lived well into the 20th century, and this photograph and others taken in their later years show that they retained the same simple hairstyle and serious expression.

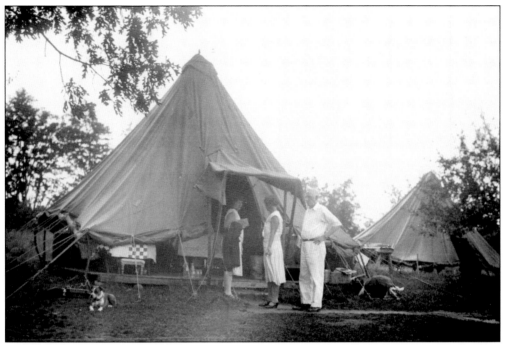

CAMPING OUT ON LAUREL STREET. These are Herman and Mabel VanderKoogh and their daughter Gladys. They were relatives of the Chapman family, and they lived in these tents in the 1930s while they were renovating their house. There is no name recorded for the dog.

A DANCE CARD. Oakdale in 1881 seems to have had a lively social life and a sense of humor. The significance of the bugs is unknown. Oakdale Hall was probably upstairs in one of the row of stores on the east side of North Main Street.

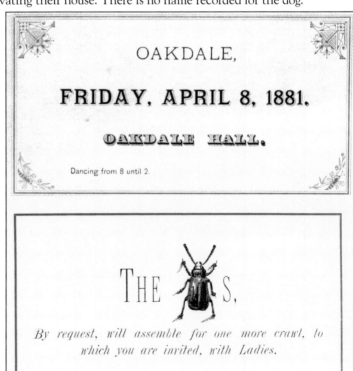

OAKDALE,

FRIDAY, APRIL 8, 1881.

OAKDALE HALL.

Dancing from 8 until 2.

THE S.

By request, will assemble for one more crawl, to which you are invited, with Ladies.

WALTER CHAPMAN AND KITTY. Chapman ran a well-digging company, which is probably the only West Boylston industry dating back to before the reservoir that is continuing in business today. It is still in Oakdale and still in the Chapman family.

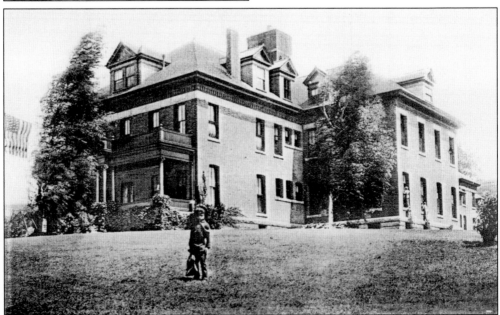

THE WORCESTER COUNTY TRAINING SCHOOL. Originally the Truant School, the building was built in 1885 on what is now Beaman Street. It was later called John Augustus Hall in newer quarters, but through all these changes it was a school for misbehaving boys. Today, the site is occupied by the Massachusetts Department of Conservation and Recreation and the department of public health.

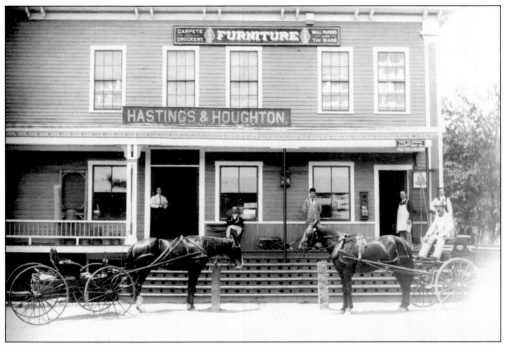

HASTINGS AND HOUGHTON'S STORE. This store was in the hotel building and sold groceries. Parker Banning, who later ran a store across the street for many years, learned the business here.

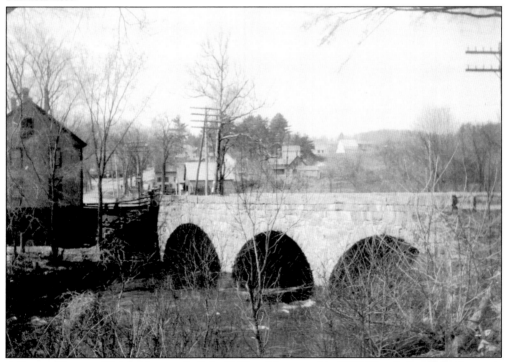

A STONE BRIDGE. This bridge was built in 1846 and destroyed in 1900. The design of the reservoir required the removal of some existing structures to be replaced by modern construction.

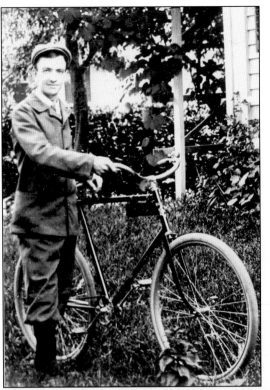

PARKER BANNING AT AGE 21. Parker Banning ran a general store and post office in the little commercial stretch that still exists on the east side of North Main Street. He was a prominent and successful citizen of Oakdale for many years, but in the 1920s, lack of business forced him to close up. He relocated his family to California in an adventurous automobile trip documented in family records.

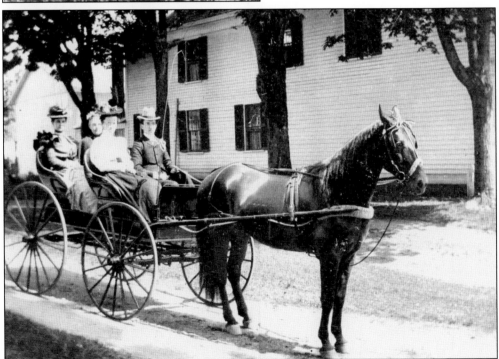

THE BANNING FAMILY. This was a family's mode of transportation between the bicycle and the automobile.

ROBERT BAILEY THOMAS. Robert Bailey Thomas was Oakdale and West Boylston's most famous citizen. Thomas originated *The Old Farmer's Almanac* in 1793 and published it until his death in 1846. It was taken up by others and has never missed a year since. The Beaman Library has the complete collection. Thomas was the first town clerk and a long-time benefactor of the town and its churches. (Courtesy of the Beaman Memorial Library.)

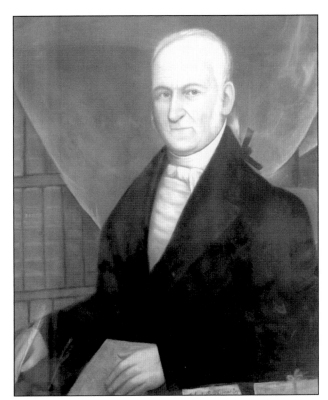

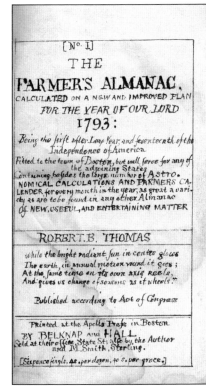

THE OLD FARMER'S ALMANAC. This is the title page of the first edition. Thomas might have technically been a Sterling resident in 1793, but in 1796, his family home became part of the precinct that would become West Boylston. The north end of Oakdale, called the "leg(g)" was at various times part of Sterling, Shrewsbury, Boylston, and West Boylston. Thomas used to joke about all the towns he had lived in without moving. (Courtesy of the Beaman Memorial Library.)

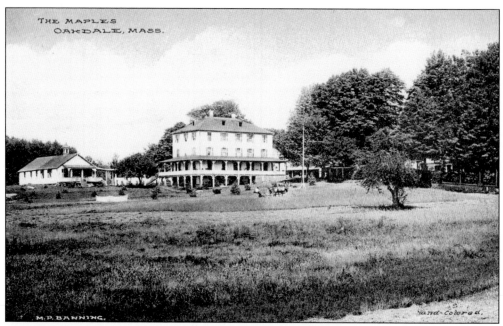

THE MAPLES. These pictures are from the Maples advertising brochure. This was a summer resort, which the *Boston Herald* called, "one of the most charming and delightful locations in New England." It stood on the west side of North Main Street, at the far end of Oakdale. It burned in the 1940s.

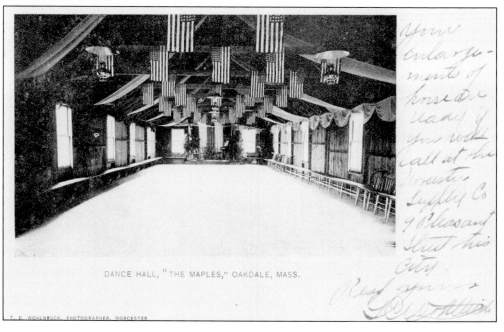

DANCE HALL, "THE MAPLES," OAKDALE, MASS.

Seven

ALL AROUND THE TOWN

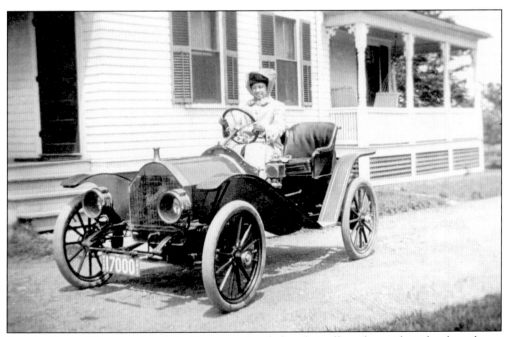

FANNY HAIR. The organist of the Congregational church is all set for a ride in her brand new Hupmobile. This seems an appropriate picture to introduce this chapter, which will be a tour of the town and its people—in no particular order of time or place, just West Boylston as it was.

WALTER B. SAWYER. The Sawyers were a prominent family in West Boylston and other northern Worcester County towns. In Sterling, it was Mary Sawyer who was followed to school by her little lamb, and the West Boylston Sawyers were probably related. Walter Sawyer had a carriage and harness business, the equivalent of a car dealership today.

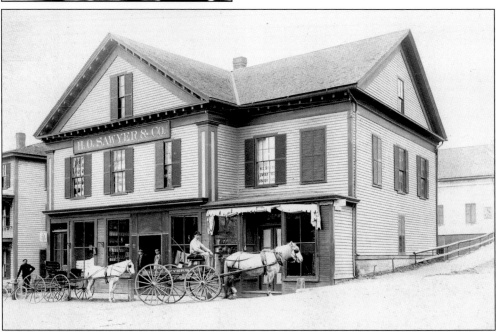

ANOTHER SAWYER FAMILY ENTERPRISE. H. O. Sawyer's store is pictured here. This was a focal point of the lower common area. The Sawyers had run a general store since early in the 19th century, selling groceries and other merchandise and operating an undertaking business from the same premises. (Courtesy of the Beaman Memorial Library.)

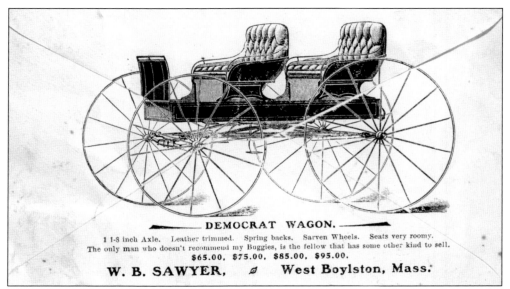

DEMOCRAT WAGON.

1 1-8 inch Axle. Leather trimmed. Spring backs. Sarven Wheels. Seats very roomy.
The only man who doesn't recommend my Buggies, is the fellow that has some other kind to sell.
$65.00, $75.00, $85.00, $95.00.

W. B. SAWYER, West Boylston, Mass.

A CARRIAGE FROM SAWYER'S ADVERTISING BROCHURE. This is one of the many models offered. The prices look amazingly low, but still not everyone could afford them. Probably the greatest expense was the upkeep of the horse.

W. B. SAWYER

CARRIAGES, BUGGIES, WAGONS, BLANKETS, AND HARNESS.

West Boylston, Mass.

AN ADVERTISMENT FOR SAWYER'S CARRIAGE COMPANY. These buildings, originally on the section of Prospect Street designated to be destroyed for the reservoir, were moved to Central Street. The main house still looks much the same, although the barns have been altered to become residences.

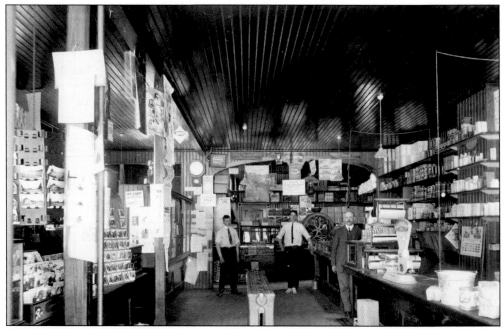

WALTER CLARK'S STORE. The picture shows a wide variety of merchandise—a true, old-fashioned general store. Somewhere they found room for the post office. It was the successor to Sawyer's store, moved from the reservoir area to Central Street. The employees are unidentified (left), Charles F. Boynton (center), and Walter E. Clark.

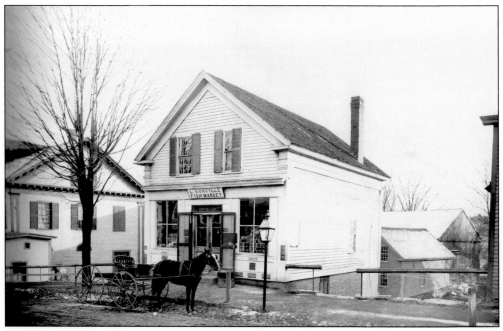

THE FISH MARKET. This was another small retail business in town. It must have been one of the Goodale Ice Company's better customers. (Courtesy of the Beaman Memorial Library.)

CHESTER MILTON SMITH. The "Lord Fauntleroy" suit was probably the height of style. At least Chester Milton Smith does not seem to mind being photographed in it.

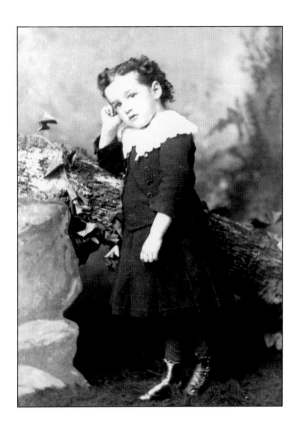

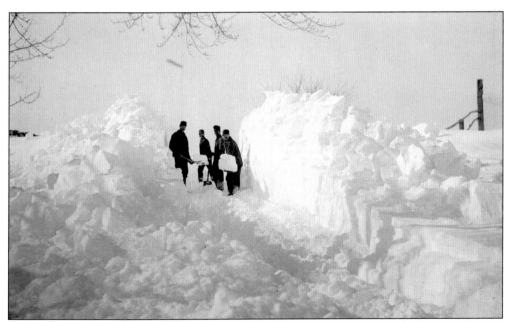

CHESTER MILTON SMITH GROWN UP. Chester Milton Smith is one of the men clearing snow from the blizzard of 1888 in this picture. Before the day of trucks with plows, the task looked overpowering.

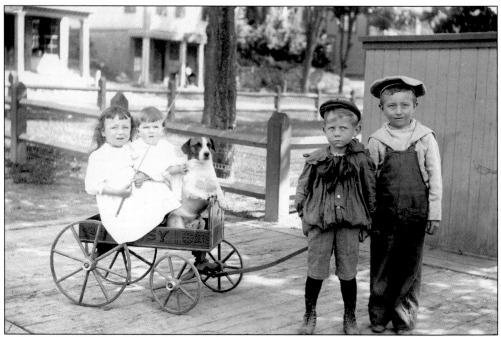

CHILDREN IN FRONT OF SAWYER'S STORE. This was in the lower common area, a little to the right of the north end of the present causeway. The children and the dog were very dignified in posing for their picture. (Courtesy of the Beaman Memorial Library.)

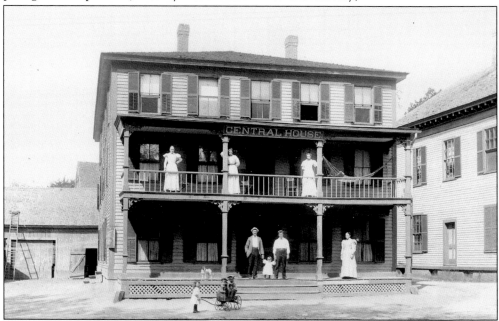

THE CENTRAL HOTEL. This was in the same area as Sawyer's store, and the children in front may very well be some of those seen in the previous picture. This was one of two hotels in town in the late 19th century, both lost to the reservoir. Neither business moved elsewhere in town, because with the mills gone there would not be any business travelers. (Courtesy of the Beaman Memorial Library.)

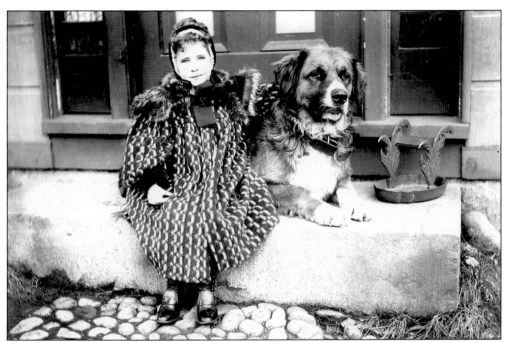

A LITTLE GIRL AND A BIG DOG. Neither the girl's name nor the dog's are known, but the picture was too perfect to leave out. (Courtesy of the Beaman Memorial Library.)

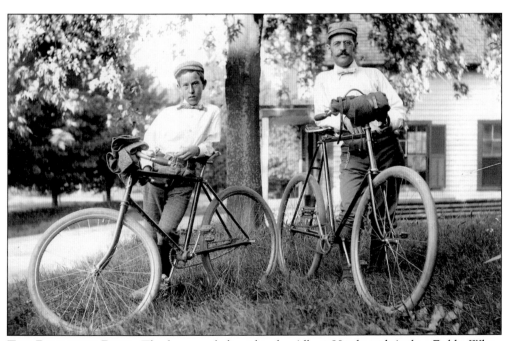

TWO BOYS WITH BIKES. The boys are believed to be Albert Hinds and Arthur Fields. When he grew up, Albert Hinds became town treasurer and is remembered for bringing a lawsuit that determined that the town and not the Congregational church owned the common. (Courtesy of the Beaman Memorial Library.)

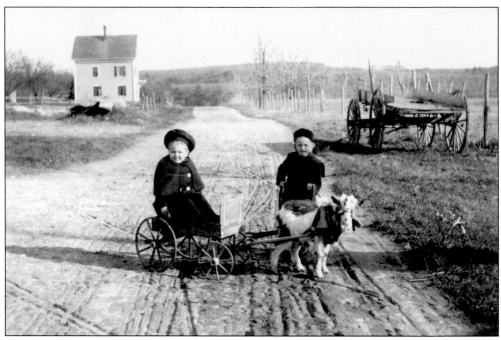

SOME MORE CHILDREN. This time the cart is being pulled by a goat. The children are Dana Higgins and Merle Wood.

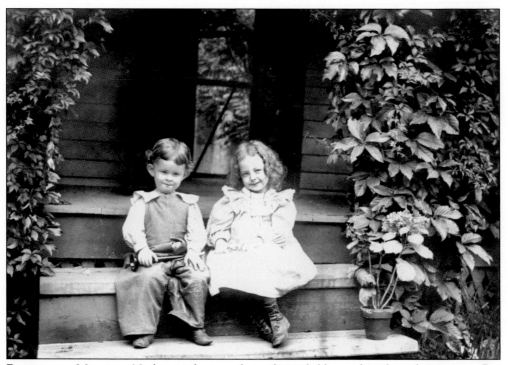

RALPH AND MILDRED. Nothing is known about these children other than their names. But look at the super-wide pants on Ralph. Things do run in cycles.

VICTORIAN STYLE. The lady is identified only as Mrs. More, wife of Amos Keyes's nephew.

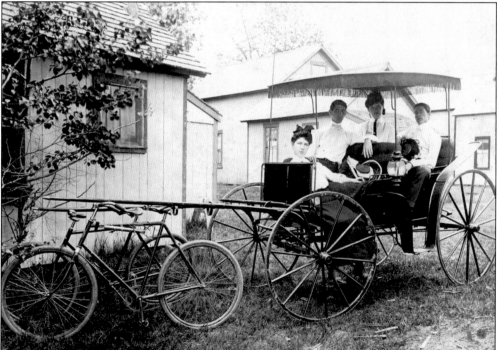

A FAMILY SCENE FROM ABOUT 1900. It is hard to imagine, but it does look as if they plan to use the bicycles to pull the carriage.

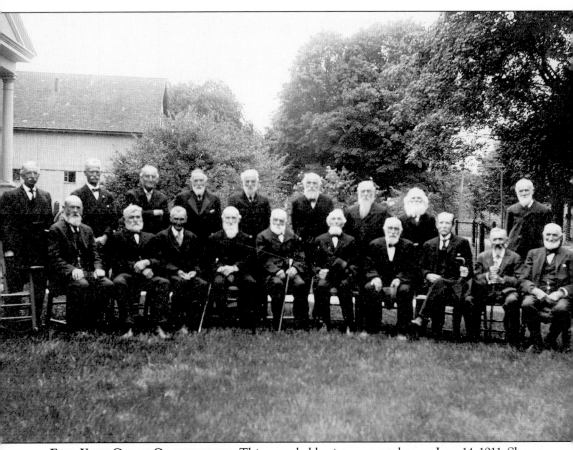

FIND YOUR GREAT-GRANDFATHER. This remarkable picture was taken on June 14, 1911. Shown here, from left to right, are the following: (seated first row) S. Higgins, J. Moran, S. Bullard, J. Keyes, A. Wood, C. Hastings, W. Keyes, W. Howe, W. Mason, and J. Johnson; (standing second row) A. Bigelow, W. Gammel, J. Toombs, L. Lesure, J. Fisher, T. Keyes, N. Rice, T. Lynch, and N. Fisher. Note A. (Ashley) Wood who was considered terminally ill four years before, see chapter three. (Courtesy of the Beaman Memorial Library.)

ALONZO DAVID WHITCOMB. An ancestor of historian Edgar Alonzo Whitcomb, to whom this book is dedicated, Alonzo David Whitcomb was one of many West Boylston Civil War soldiers. Enlisting twice, he served during most of the war, from 1861 to 1865, and was wounded at Cold Harbor, Virginia, in 1864.

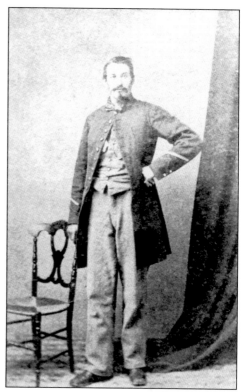

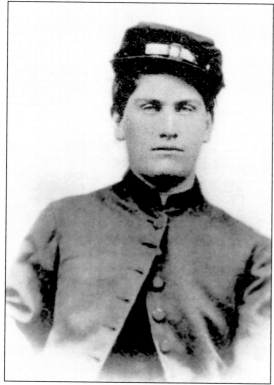

GEORGE BLUNT. Another West Boylston boy, Blunt enlisted after his brother William was killed at Gettysburg. He was another wounded at Cold Harbor, losing an arm on June 2, 1864, the day before Alonzo Whitcomb was hurt. His handicap however did not keep him from serving as a mailman in Worcester for many years. (Courtesy of Rockie Blunt.)

NELLIE GOODALE. She was the daughter of Lucy Walker Merriam (see chapter six). She married Aaron Goodale IV and was the mother of Aaron Goodale V. (Courtesy of Aaron Goodale.)

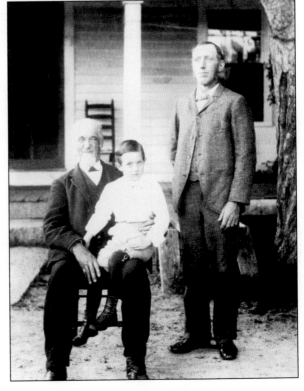

THREE GENERATIONS. Aaron Goodale III, Aaron Goodale IV, and Aaron Goodale V are shown here at the brick homestead on Goodale Street. There has been an Aaron Goodale in every generation since the 18th century. The present Aaron Goodales are the seventh and eighth. (Courtesy of Aaron Goodale.)

ABRAHAM HENNESSY. Abraham Hennessy was a caretaker in Mount Vernon cemetery for over 25 years. A newspaper article in 1921 said that he had dug over 600 graves. The paper noted that he was at that time the only black person in town. He also sang in the Congregational church choir for 42 years. He wanted very much "when his time came" to be buried in his cemetery, the trustees assured him that he would be, and carried out his wishes. (Courtesy of Norman Goodale.)

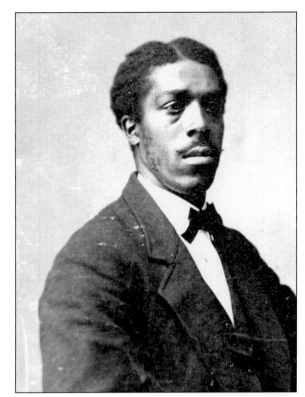

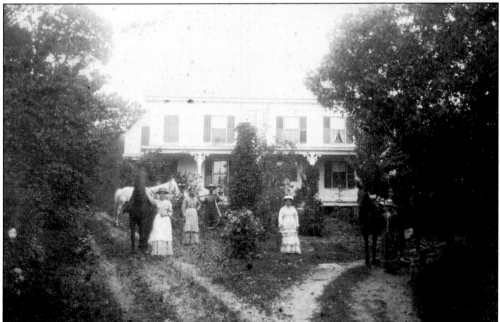

A GOODALE FAMILY GROUP. This picture, taken at the Goodale house on Laurel Street, shows Lefie Goodale (second from the left), her daughter Mary Mason Goodale (center) and her son William Mason Goodale (right). The house is still in the Goodale family. (Courtesy of Norman Goodale.)

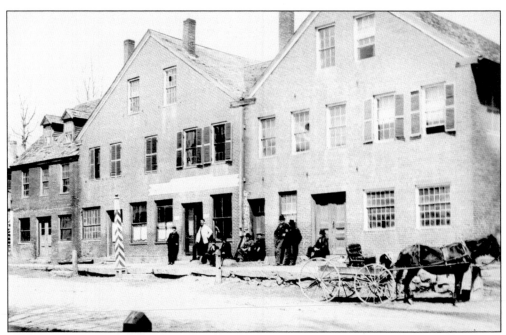

OUTSIDE THE BARBER SHOP AROUND 1900. These brick buildings, which do not look at all like West Boylston, were on East Main Street in the lower common area. It is hard today to imagine a row of tightly clustered commercial buildings like these ever having marked the center of town.

THE WEST BOYLSTON POLICE STATION WITH TWO OF THE CONSTABLES, 1900. The police station stood in the lower common area (to the right of the far side of the present causeway, going north). One of the officers would be William Burns, West Boylston's first professional policeman, who had the additional distinction of being the first person to move his house when displaced by the reservoir. It now stands on Scarlett Street.

110

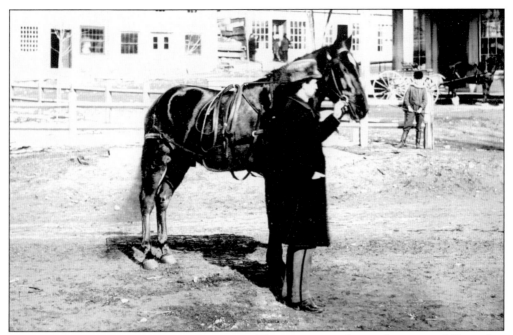

A Scene in 19th-Century West Boylston. This image was taken at the corner of Clarendon and East Main Streets. The date of the picture is unknown, but from the appearance of the clothes and the fact that it is a tintype, it is probable that this is one of the earliest West Boylston photographs in existence.

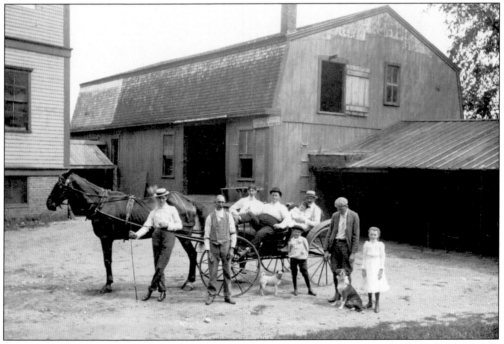

D. Nault's Livery Stable. The livery stood on Clarendon Street in back of Sawyer Hall. Clarendon Street was in the old center and is now under water a little east of the causeway. Sawyer Hall was moved and became Reed's Organ Shop and is now Wayside Antiques.

A House on Church Street. Built *c.* 1790, this house has belonged at various times to the Brigham, Houghton, and McCormick families. Church Street is a West Boylston oddity—it is split into two sections, which are set at right angles and separated by a major intersection. Another of these is Central Street, which takes a sharp turn to the right, with the portion straight ahead becoming Crescent Street.

Tatro's Blacksmith Shop. This was on Lower Prospect Street near Sawyer's Carriage Shop. The carriage shop was the place to buy a new buggy, and horses could be shod nearby at the blacksmith shop.

THE ANDREW SCARLETT HOUSE. This handsome Queen Anne on Worcester Street was ordered by Andrew Scarlett from the Sears Roebuck catalogue. Around the beginning of the 20th century, Sears actually sold houses this way. Scarlett ordered another built across the street for his mother. That house is now Our Lady of Good Counsel Rectory.

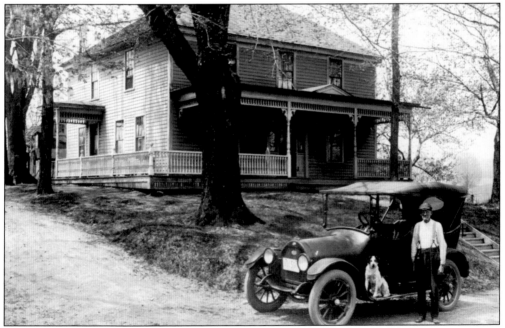

ANDREW NEWTON IN FRONT OF HIS HOUSE ON TEMPLE STREET. That might have been a brand new car. The house, also shown in chapter one, is still standing, though without the porches. It was built in the 1770s by Abel Bigelow, the innkeeper of the Historical Society's Bigelow Tavern. The house was also home to the founders of the Bigelow Carpet Company in Clinton.

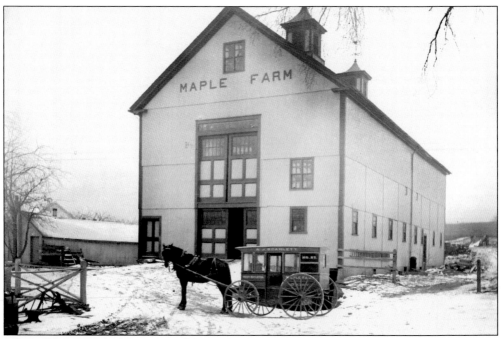

MAPLE FARM. At the beginning of the 20th century, this setting looked very rustic, but it was right in the center of town on Worcester Street, where the pumping station is now. The farm was owned by Andrew Scarlett, who went from dairy farming to real estate development when the reservoir came.

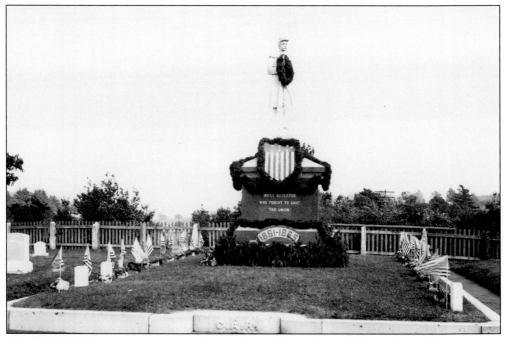

THE CIVIL WAR MONUMENT IN MOUNT VERNON CEMETERY. This picture dates from shortly after the monument was erected in 1895 by the Ladies' Relief Corps, the women's auxiliary of the Grand Army of the Republic.

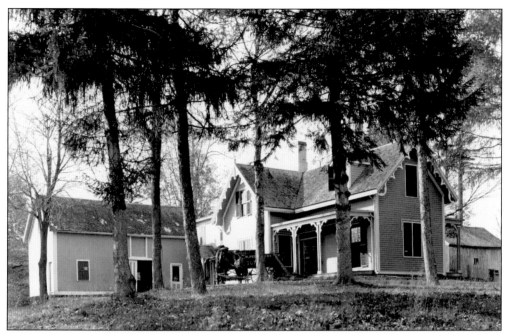

ROSE COTTAGE. This is West Boylston's best example of the picturesque Carpenter's Gothic style, which was popular in the mid-19th century. Unlike so many other houses shown in this book, Rose Cottage shows very little change in the 100 years since this picture was taken. Pearl McGowan ran her very successful rug hooking business from this spot.

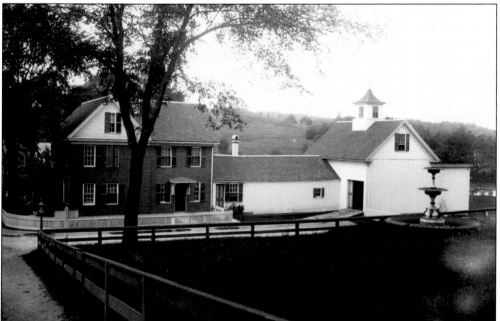

THE G. F. HILDRETH HOUSE. This building stood across the street from the Old Stone Church. G. F. Hildreth was associated with the Cowee mill, which stood at the end of the same street. The fountain in the yard was preserved when the house was destroyed for the reservoir. It spent some time in Mount Vernon Cemetery, but the fountain's present whereabouts is unknown.

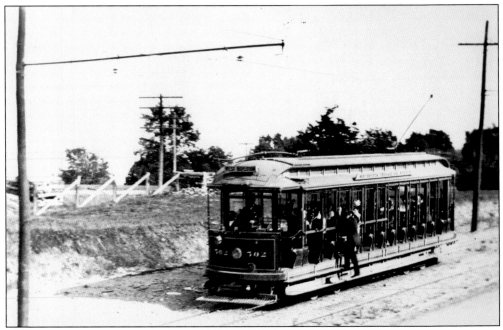

A Trolley Going through West Boylston, Headed North. The picture was taken from in front of Rose Cottage, apparently in the summer, as indicated by the open car. The trolleys ran from about 1905 to 1928 on what is now Route 12. On the West Boylston Street section of the route there were only trolley tracks; the road came later.

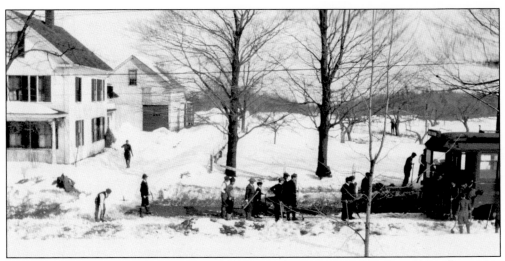

Clearing the Trolley Tracks on Worcester Street Early in the 20th Century. Without a plow it took a large crew of shovelers—this job was a necessity; but clearing the rest of the roadways was still a new thing. Before automobiles became common, it was better to leave some snow in the road to make it easy for the sleighs.

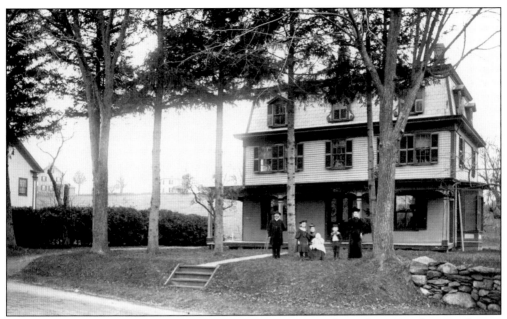

THE DEACON MURDOCK HOUSE ON PROSPECT STREET. In the early 1800s, this was the site of the first Sunday school in town, and later on, the home of the Beaman Club. This picture probably dates from around 1900. The house was built in 1801 and the Mansard roof and porch were probably added in the 1860s. Notice the lack of trees, allowing a view of houses on Newton Street.

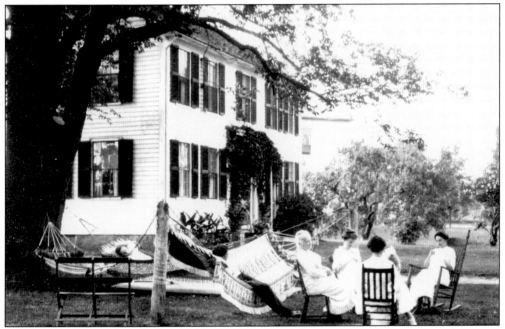

A PLEASANT SUMMER DAY. The ladies were on the lawn of the Howe/Cummings house on Church Street in August 1914. This house has recently been restored, but with very little change in appearance. It is still in the same family. The house was built in the 1830s on the site of the former home of Joseph Bigelow, one of the donors of land for the adjacent common.

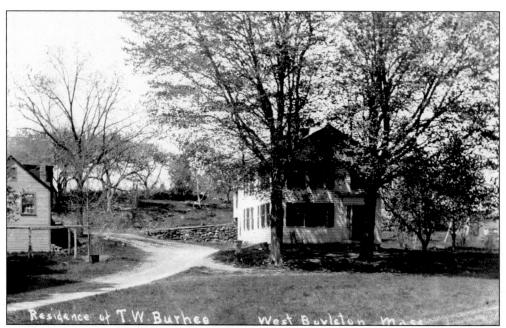

Residence of T. W. Burhee West Boylston Mass

CHURCH STREET IN 1913. The name for this street came from the Baptist church when it was built here in 1902. Previously, these houses had addresses on Central Street. This photograph was taken at the opposite end from the church. The Fay Funeral Home building would be just out of sight to the left. (Courtesy of Dennis Parker.)

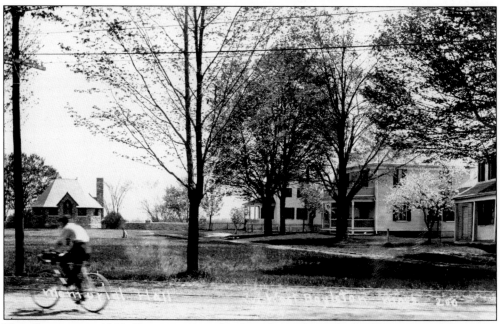

THE COMMON IN 1913. Here is a scene that has changed very little. We see one of the many bicycles that appear in these old pictures, they can still be seen today, although a few cars would be in the picture as well. In the background is the Holbrook Chapel. (Courtesy of Dennis Parker.)

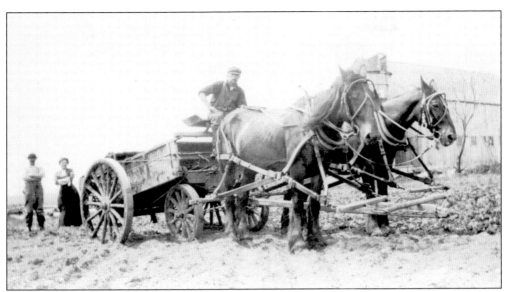

FARMING IN WEST BOYLSTON. Shown on the buckboard is Alden Brigham, driving Andrews' team, on Hartwell Street.

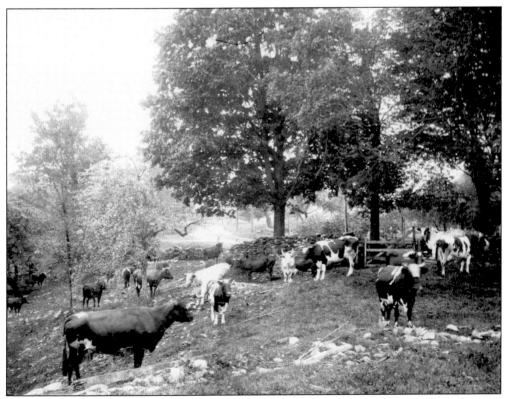

WHEN WEST BOYLSTON HAD DAIRY HERDS. The cows are on Andrew Scarlett's farm on Worcester Street in the center of town. The dirt road in the background shows where the street begins to turn towards Worcester. As the name indicates, this was the main road into the city until Route 12 came in the 1920s.

THE WARNER GIRLS. They are Helen Reed Warner, 12, and Louise Marsh Warner, 5, daughters of Waters and Mary Jane Warner. The picture was taken about 1895.

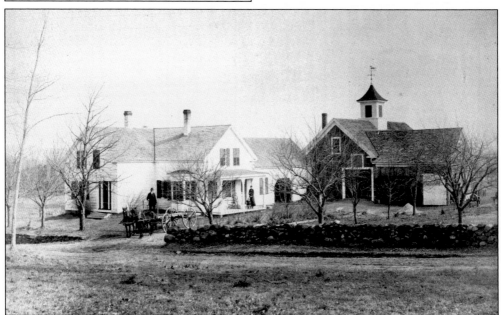

WATERS WARNER'S FARM. Waters Warner and his first wife Mandana bought this place on Malden Street from her father, Charles Goodale. After she died, he married Mary Jane Reed, another prominent West Boylston name. It was here that their daughter Helen was born in 1883. The house and barn escaped the reservoir because of their location, but were destroyed by fire in 1903.

MAJ. VICTOR EDWARDS. Major Edwards gave the land for the school that was named for him. He was an engineer and inventor, with over 100 patents in his name. A Worcester Polytechnic Institute graduate and honorary degree recipient, he worked for several major companies, most notably Morgan Construction Company. His military rank came from service in the army in World War I. He lived 20 years in West Boylston and was active in town affairs. (Courtesy of the Edwards School.)

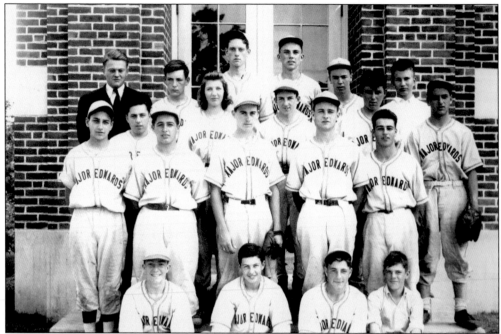

THE MAJOR EDWARDS HIGH BASEBALL TEAM, 1941. The players are, from left to right, as follows: (first row) Bob Soule, Donald Stewart, Joe Baccachiocci, and Burton Childs; (second row) Allan Howe, Jimmy Bonci, Jerry McCabe, Billy Allen, and Earl Belles; (third row) Francis Bonci, Carolyn Hudson, Red Holmes, Billy Cummings, and Vernon Carima; (fourth row) Leroy Houghton, Bob Nogle, Jimmy Coffin, and David Kendall; (fifth row) Bob Potvin, and Greg Gardner. As apparent from the roster, women started participating in male sports earlier than might have been thought.

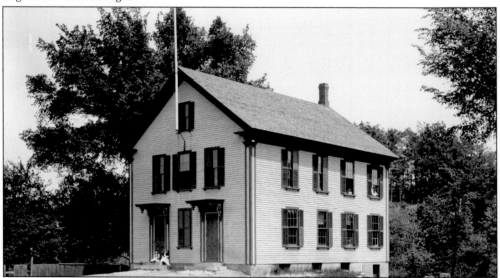

THE NORTHEAST SCHOOL. In the 19th century there were several small schoolhouses, a convenience for all the neighborhoods. This one stood on Lancaster Street, and is typical in appearance. After the reservoir reduced the population, the small schools were consolidated into the Goodale School.

THE BULLARD HOUSE AND THE BULLARD FARM. Located on what is now known as Bullard's Hill (Thomas Street), the farm fell to the reservoir construction. The site of the house today is part of the land occupied by Major Edwards School.

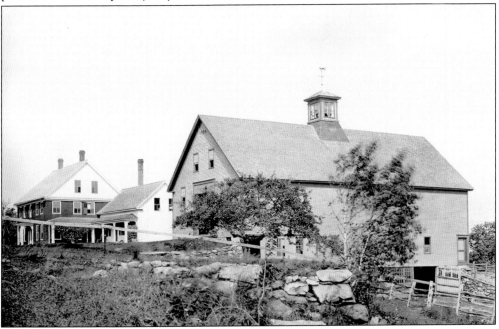

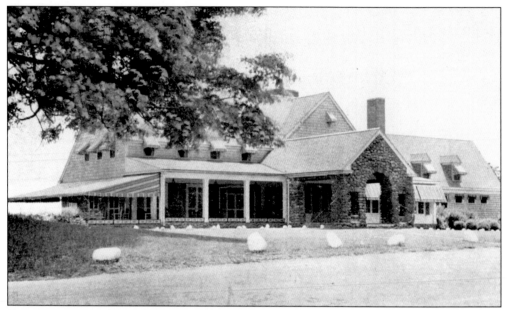

THE WACHUSETT COUNTRY CLUB. The picture was probably taken shortly after the Wachusett Country Club was built in 1928. The buildings were built on land first settled by Edward and Sarah Goodale in 1738.

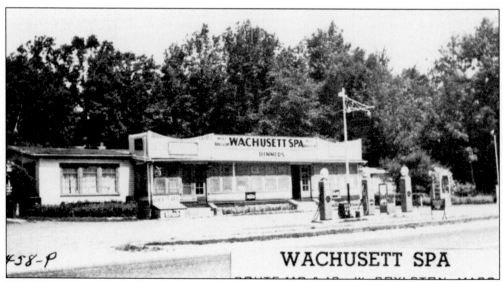

THE WACHUSETT SPA. The Wachusett Spa was on Sterling Street near Holt Street, and the picture comes from the 1930s or 1940s. The buildings are still there, although like most old commercial buildings, they are much different now.

W. AND M. GARAGE. This advertising card is from the early 1930s. From about 1928, the garage was on Worcester Street where the Reservoir Garage is today. Many will remember the site as Armstrong's Garage. (Courtesy of Dennis Parker.)

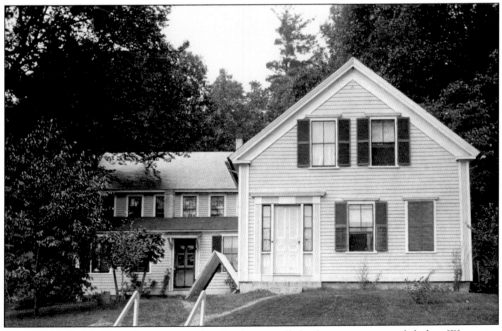

OVENDEN'S SHOP. Ovenden was a mechanic who actually built a steam automobile for a Worcester man. This was the beginning and the end of the automotive industry in West Boylston.

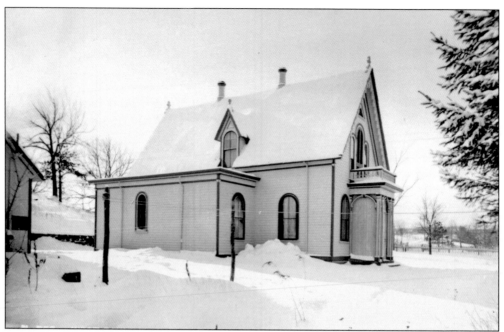

THE SILAS DINSMORE HOUSE. This house stood to the east of Worcester Street, beyond the railroad tracks on what is now state land. It was moved to Central Street where it was once the Flagg Funeral Home. It still stands, much enlarged and altered, but retaining its picturesque Victorian Gothic and Italianate style.

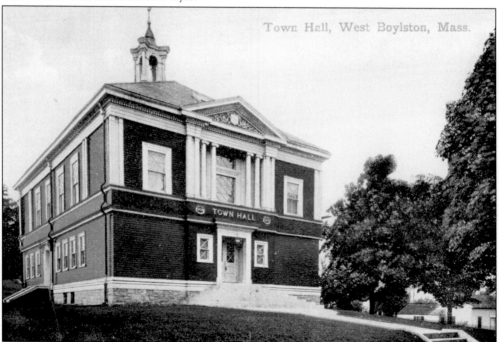

Town Hall, West Boylston, Mass.

THE OLD TOWN HALL. The old town hall stood at the corner of Crescent and Prospect Streets, where the light department is now. Along with town offices, it housed the library until 1912. Built after the reservoir, the hall had only a short history. It burned in 1917 and was not replaced.

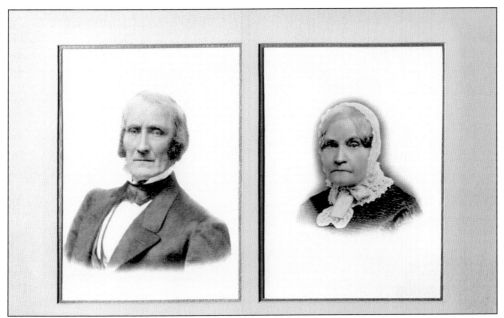

DAVID LEE CHILD AND LYDIA MARIA CHILD. They were among the most prominent abolitionists before the Civil War. He was a West Boylston native who served as a diplomat and brought the production of sugar from beets to America. As well as an abolitionist, she was a women's rights advocate and the author of the Thanksgiving Day favorite *Over the River and through the Woods*. (Courtesy of the Beaman Memorial Library.)

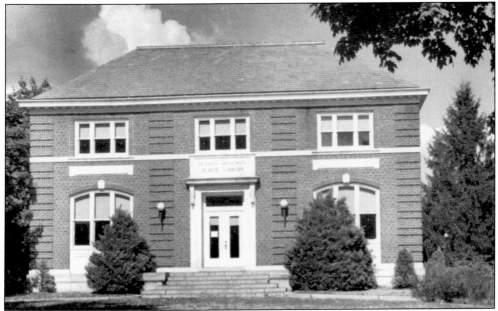

THE BEAMAN MEMORIAL LIBRARY. G. Calvin Rice donated the money to build a library dedicated to his ancestor, Ezra Beaman. The original building, built in 1912, still looks as it did in this view but with a large addition built behind it in 1999. The money for the original library in 1878 came from the will of David Lee Child, and Lydia Maria Child donated her personal book collection.

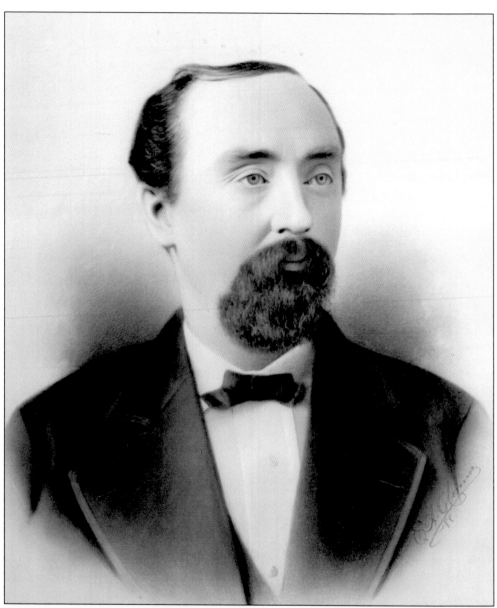

Sergeant Plunkett. Thomas Plunkett, West Boylston's outstanding Civil War hero, came from Ireland as a young man, settled in West Boylston, and worked in a shoe shop. Like many of his countrymen, when the Civil War began, he enlisted in the Union Army. He was promoted to color sergeant, in charge of the all-important flag bearers who marked a unit's position on the field. On December 14, 1862, at the battle of Fredricksburg, Plunkett saw his flag bearer fall. He picked up the flag and carried it himself until he was hit in both arms. Legend says that he then carried it in his teeth till he collapsed, apparently mortally wounded. Nursed, they say, by Clara Barton, he survived, although losing both arms. He returned to a hero's welcome and was given a job as a doorkeeper in the Massachusetts State House. He married and had a family. When he died in 1885, he was given a state funeral in Mechanics Hall in Worcester. His portrait now hangs there on the wall alongside statesmen and Worcester notables. (Courtesy of the Beaman Memorial Library.)